11/19/06

IMAGES
of America

MONROE
THE EARLY YEARS

Cover: General Custer is pictured surrounded by his Indian Scouts on an expedition to the Black Hills in 1874.

IMAGES
of America

MONROE
THE EARLY YEARS

Craig E. and Kimberly A. Hutchison

ARCADIA

Published by Arcadia Publishing
Charleston SC, Chicago, IL, Portsmouth NH, San Francisco, CA

Printed in Great Britain

Library of Congress Catalog Card Number: 0738533742

For all general information contact Arcadia Publishing at:
Telephone 843-853-2070
Fax 843-853-0044
E-mail sales@arcadiapublishing.com
For customer service and orders:
Toll-Free 1-888-313-2665

Visit us on the internet at http://www.arcadiapublishing.com

These pages are dedicated to the gift of life given to us by our Creator.
May we, the living, not take life for granted,
but instead, follow the precept given by Ralph Waldo Emerson,
one of the most insightful philosophers and writers in history:
"Do that which is assigned you,
and you cannot hope too much or dare too much."

CONTENTS

ACKNOWLEDGMENTS

The development and authorship of this book have been one of the most enjoyable experiences of our publishing lives. One of the main reasons it has been such a great experience is the people we have had the pleasure to work with. We first want to thank Matthew Switlik and Ralph Naveaux of the Monroe County Historical Museum for giving their approval so that this project could move forward. While parsing through the vast amount of information and images in the archives at the museum, Chris Kull and Lynn Reaume were nothing short of tremendous. The knowledge, professionalism, and kindness they displayed throughout the entire process is something that we will never forget and for which we can never thank them enough. The world of history needs more people like them. Our appreciation would not be complete without mentioning Geri Dvonch; she always greeted us with a warm smile, a word of encouragement, and went out of her way to help us in any way she could. Geri is a true asset to the museum. Two history professors also deserve a word here—Dr. Gerry Moran and Dr. Marty Hershock conveyed more about the study of history than they will ever realize and we consider them two of the greatest historians on this earth. We also want to thank all of our friends for their encouragement, as well as Mom and Dad for their unfailing support. With a heart of appreciation, we thank most of all our Heavenly Father who lent us a few talents to be able to create this book, which will hopefully mean much to many.

Craig E. Hutchison
Kimberly A. Hutchison
www.wanderingwolverine.com

INTRODUCTION

Monroe is one of the oldest settlements in Michigan. The history of Monroe, as that of many areas that were on the frontier, is closely connected to the presence of a river. Waterways have served as a means of survival for human beings throughout history. Rivers and lakes have determined the location of numerous settlements, and this is certainly true with the Monroe area. Flowing along with the River Raisin is a rich and interesting historic timeline that details the different eras of Monroe's past.

Years before the first European settlers came to the area, Native Americans reached it via Lake Erie in their birch bark canoes, paddling up the river they called "Nummasepee" or "River of Sturgeon." Everything needed to sustain life was either in or around the river: fish, birds, and other animals filled the marshes and creeks. Trees were filled with various nuts, berries, and syrup. The Native Americans lived a nomadic life and the Monroe area was a popular camping site because of its abundance. French missionaries visited the area as early as 1634 and named the river "Riviere aux Raisins" because of the numerous grapevines that lined the banks. The first permanent white settler was Francois Navarre, who moved to the area from Detroit in 1780. Navarre built a cabin on the south side of the Riviere aux Raisins on land that was deeded to him by local tribes. Within a few years, close to 100 French families followed him and set up farms along the river. This first settlement became known as Frenchtown.

When Americans started to make their way west to settle in the Michigan territory, the British were determined to continue to control the area because of the lucrative fur trade and because control of the Great Lakes was strategically advantageous. When the War of 1812 broke out, Frenchtown found itself in the middle of a very important region. The Battle of the River Raisin was the single most deadly battle for the United States during the entire war. To make matters worse, over 60 unarmed American wounded were massacred by Native Americans after the battle. "Remember the River Raisin" became the battle cry during the rest of the war. The destruction was so severe that the settlement around the River Raisin remained impoverished for five years.

After the Americans proved victorious in the War of 1812, the settlement grew slowly. In 1817, the area became known as Monroe in honor of President James Monroe, who had served as both Secretary of State and Secretary of War, as well as the first President to visit the Northwest Territory. With the completion of the Erie Canal, settlement increased and Monroe became Lake Erie's only commercial port. Monroe became even more connected to outer regions when the Michigan Southern Railroad was completed in 1841, linking Monroe to New Buffalo (on the eastern shore of Lake Michigan). As more settlers traveled west, the talented people needed to develop the area arrived: farmers, storekeepers, lawyers, physicians, school

teachers, preachers, blacksmiths, mill operators, and more.

Monroe's most famous son, George Armstrong Custer, went to school and met his future bride, Elizabeth "Libbie" Bacon, here. During the Civil War, Custer fought as a cavalry officer in many of the major battles, including Bull Run, Chancellorsville, and Gettysburg, and he was also present at Appomattox. He rose to the rank of brevet Major General during the war. He rose to national fame due to his Civil War exploits. At the close of the war he was mustered out of the service as Lieutenant Colonel of the Seventh Calvary and went with his command to Texas. Thus began his long service on the western plains, extending from Texas to the Black Hills and the northern boundary, where he won fame as an Indian fighter and met his tragic death at the Battle of Little Big Horn in 1876.

The rest of Monroe's sons also served valiantly in the Civil War. No county in the country had a higher number of volunteers, proportionately, than Monroe County. Monroe men were mustered in the Fourth, Seventh, Fifteenth, Seventeenth, and Eighteenth Michigan Regiments. A number of Monroe men earned the Congressional Medal of Honor. Monroe, just like the rest of the nation, cheered and celebrated when the Confederate army surrendered to end the war. The celebration turned to mourning, however, when just a few days later, President Abraham Lincoln was assassinated.

In addition to these historical eras, other arenas of life have figured prominently in Monroe's history, including the formation of its churches and the architecture of its dwellings. These topics provide very interesting stories, many of which are shared in the following pages. The intention in the development of this book was to share as much of the rich heritage of the Monroe area as possible within the constraints of time and space. Please bear in mind that everything that has ever happened during the history of Monroe could not, unfortunately, be covered because of the considerations stated above. What is covered in the following pages are topics that the writer felt would be interesting and that share as much of the wonderful heritage of the Monroe area as possible. The time period covered is basically from the Native Americans and the early settlers to the late 1800s. This leaves open the possibility of a second book in the future.

It is hoped that the reader will find this work informative, insightful, and interesting. The Monroe area has much to be proud of in its heritage and this book is intended to be a tribute to the region. There is something that exists in human beings that yearns to make a connection with the past: "He is lifted beyond and above himself into higher worlds where he talks with all his great ancestors, one of an illustrious group whose blood is in his veins and whose domain and reputation he proudly bears." If the reader can identify with this statement after spending time with this book, it will have served the purpose with which the authors started out. Enjoy the images, the text, the people, places, and stories of Monroe.

One

EARLY INHABITANTS AND FRANCOIS NAVARRE

French missionaries visited the River Raisin as early as 1634. There they found Native Americans, specifically, the Potawatomi tribe, which had been attracted to the area for the abundance of food and resources that existed in and around the river. They could travel freely along the shores of Lake Erie in their birch bark canoes and then up the meandering river which provided them with easy access to the interior of the land. The river was full of huge sturgeon, black bass, and whitefish. Ducks, geese, swans, and muskrat filled the marshes. Beaver, mink, and otter were in and around the creeks. Berries and walnut, hickory, and chestnut trees provided fine delicacies. In the spring, maple trees flowed with sap, from which the Native Americans made syrup and sugar. The fall was harvest time for wild rice in the marshes. The squaws paddled through the marshes, beating the rice plants over the edge of the canoe in order to fill the bottom of the craft with grain. The Potawatomi were a nomadic people who lived off the land. Their villages were only winter campsites. Other than the abundance of food, the Monroe area was a popular camping place because it was on the Saginaw Trail, one of the main trails in the area. The trail (today known as US-25) led south from Saginaw Bay through the area now known as Monroe and connected with the Great Trail that ran from Chicago through present day Toledo.

The Native American villages were a collection of crude buildings that served their purpose well as groups came and went. Fish was the mainstay of their diet. Corn was made into cornmeal, bread, and soup. Corn silk and pumpkin blossoms were used for flavoring or thickening broth. Wild plants were gathered for food and milkweed flowers were stewed for preserves. Moss on white pine was used to freshen up the water. Tea was made from tree bark. Clothing was made from animal skins. Low benches made of sticks and brush, covered with fur or mats, were used as beds. Plants and herbs were gathered, dried, and mixed to be used as medicines. While the men hunted or went fishing, the squaws worked in the fields where they grew corn, potatoes, and squash—sharing the crops grown throughout the community. The squaws wove mats, made moccasins, leggings, embroidered using porcupine quills, gathered fruit, made hominy, and dried venison.

The first permanent white settler to the area was the French-Canadian Francois Navarre,

who arrived in 1780. The chiefs of the Potawatomi village welcomed him and gave him land. This was recorded in a deed in 1785. Each chief signed his name with a symbol. The generosity of the Potawatomi was seen again the next year when they agreed to give up more land on the north side of the river for a Catholic Church. About 100 French families followed Francois Navarre and built a settlement called Frenchtown on the north bank of the River Raisin just a few hundred yards northeast of the present-day Winchester Street Bridge. The houses they built were enclosed in palisades made with split logs driven into the ground. Following their custom, the houses were built only a short distance from each other with their farms extending in narrow strips back from the river. These early settlers and the Native Americans got along well together and many Potawatomi converted to the French-Canadians' Catholic faith. The harmonious relations can be seen in the marriages between the natives and the new residents. Also, the fur trade contributed to the close ties. The birch bark canoes of the Potawatomi were up to 35 feet long and could carry large quantities of cargo, including furs which were transported from interior regions to trading posts.

Francois Navarre is considered to be the "Father of Monroe." His importance to the area cannot be overstated. After building a log cabin on the land deeded to him on the south side of the River Raisin, he was the first person to attempt the establishment of military discipline and to introduce a form of civil government in the area. He was appointed Captain, and afterwards, Colonel, in the first regiment formed on the River Raisin. Colonel Francois Navarre was one of the first grand jurors at the first court held in Frenchtown in 1805. He held numerous distinguished civil offices including Justice of the County Court. He maintained a great influence over the Native American tribes throughout his life. Colonel Navarre was thoroughly familiar with their habits and mode of warfare, and spoke with ease several of their languages. He served as a colonel in the War of 1812, in which 36 Navarres enlisted and fought side by side. Colonel Navarre was well-educated and a very polished gentleman. General Alex Macomb appointed Navarre to guide, direct, and trace the war road on July 13, 1816. Colonel Francis Navarre was recognized by the British as a man of power and influence. He was hunted for his service as an American spy, was captured twice by the British, and twice escaped. At the close of the War of 1812, he returned home to find none of the former comforts of Frenchtown, but instead, desolation and devastation. He helped to rebuild and never gave up on the ambition of his early years: to build a home in the wilderness. He died on September 1, 1826 and was buried in St. Antoine cemetery on the River Raisin. Perhaps the best tribute that could be written about Colonel Francois Navarre was written as part of his obituary:

> He witnessed the first commencement of a fine settlement here, saw the same settlement destroyed, the homes of the inhabitants sacked and burned upon the battlefield, and finally lived to see the remaining inhabitants recover from the shock of the war, settle themselves anew in comparative affluence, and build up a flourishing village within a few rods of his own door. Through his life he was remarkable for his habits of temperance, industry, and frugality. He was hospitable to new comers in the early settlement of the country, and was noted for the strictest honesty and uprightness in all his intercourse with mankind.

Known today as the River Raisin, Monroe's waterway was first called "Nummasepee" or "River of Sturgeon" by the Native Americans that roamed through the area. The French renamed it the "Riviere aux Raisins" because of the abundance of grapevines that lined the banks. The history of Monroe is tied to this waterway. The Native Americans used the river to travel into the interior of the land and back to Lake Erie. Also, Native American villages were usually established close to water to gain access to the abundance of fish and fowl. The River Raisin was full of sturgeon, black bass, and whitefish.

The River Raisin was also a haven for ducks, geese, swan, muskrat, beaver, mink, otter, deer, buffalo, and bear, which provided food and clothing for all the settlers that came to live near its shores. The river and surrounding area provided everything needed to sustain life. The French who settled in the area created farms that had one edge along the river so as to have access to water for their crops.

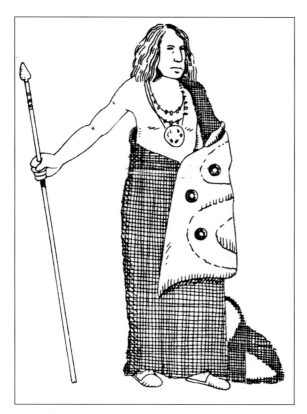

This drawing, recreated from one produced by the Chicago Natural History Museum, depicts a Potawatomi man from Michigan in about 1600. The fur robe and other artifacts are based on archaeological evidence. The Potawatomi tribe was the main tribe to use the River Raisin. Maple sugar was available, wild rice grew in Monroe-area marshes, corn was grown for cornmeal, wild plants for food, and herbs for medicine. It is known that the Potawatomi were in the Monroe area as early as the 1630s, when French missionaries arrived. It is unknown how long they had been in the area prior to this time.

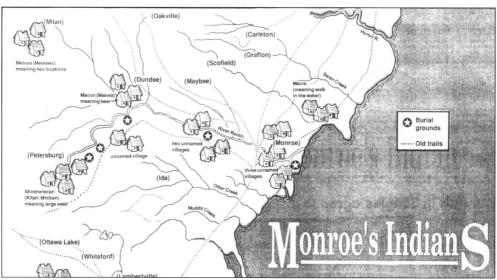

This map shows the location of Potawatomi villages in Monroe County. The map indicates that there were three villages, two south and one north of the River Raisin, in what is today Monroe. This map was based on Dr. W.D. Hinsdale's Indian map as shown in the *Michigan Archaeological Atlas*.

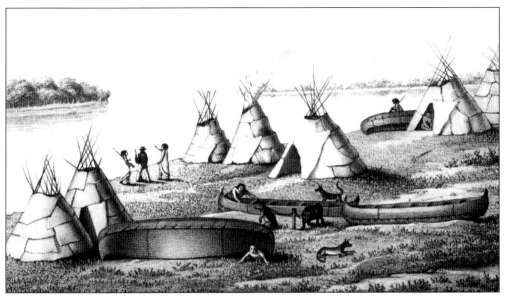

The villages were a collection of crude buildings. Young trees were cut and placed in the ground in an oval shape and the tops were bent over to form a roof. The frames were covered with dirt, grass, and bark. A hole was left in the top to permit smoke from the fire inside to escape. There was also an opening on the side, used as a door, which was covered with animal skin. Each hut was used by several families. (Courtesy British Library.)

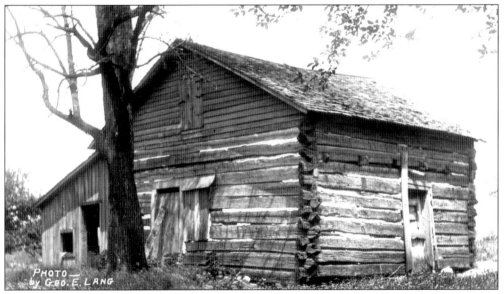

In 1807, the United States government created a reservation for Native Americans at Macon, just north of Dundee. Many of the Potawatomi in the River Raisin area were relocated to this reserve. As settlement continued, the Native Americans were relocated again to other parts of Michigan, Oklahoma, and Kansas. Some Native Americans moved away from traditional lodging and built cabins. Pictured here is an Indian log cabin that was built in 1811. (Courtesy George E. Lang.)

The original deed of land to Francois Navarre was signed by the chiefs of the Potawatomi village. The Potawatami welcomed Navarre and gave him 20 acres of land on the south side of the River Raisin. The deed was recorded in 1785 with each chief signing his name with a symbol. Askiby was represented by a rabbit; Ona-oni-attene was represented by a fish; Sac-co-ni-binne was represented by an elk; Minguinan was represented by a bear; and Nana-onite was represented by a beaver.

This is a translation of the original deed of land from the Potawatomi to Francis Navarre signed on June 3, 1785. The symbols by which the Chiefs signified their adherence to the deed are clearly spelled out. The characters used as signatures were drawn upside down which denoted that the animal or fish had been killed. This was the beginning of the permanent settlement of the area. Francois Navarre is remembered today as the "Father of Monroe."

COPY OF ORIGINAL DEED

Soon after settling along the River Raisin in 1780 Francis Navarre began bargaining for the right, title and interests of the Pottawatamie tribe, for the site now occupied by the city of Monroe. The original deed executed by the Indian chiefs was written in the French language and it is now in the hands of J. Alexander Navarre, a great grandson of Col. Francis Navarre. Following is a translation into English of the deed:

We, the principal chiefs of the Village of the Pottawatamies, to wit: Askiby, Mongo,agon, Minguinan and Ona-oni-attene, Nana-onito, Sac-co-ni-binne, as well, in our names as by the consent of our village, declare that of our good will we have conceded to Francis Navarre, surnamed "Tchigoy", and to James, his brother (both our allies), all the extension of land which belongs to us upon the bank of the River Raisin, formerly called Namet Cybi, commencing to take from the river road (as filed in court) to the end of the prairie, going up the stream Namet Cybi, allowing more or less twenty acres in width by eighty or one hundred in depth; the whole may be determined by a line lengthwise south and a league north in width, going up the river Namet Cybi, in order to possess on the whole in all propriety and perpetuity by themselves and their representatives. In faith and testimony of which we have freely made our ordinary marks as signature in Detroit, June 3, 1785.

Askiby	(Represented by a Rabbit)
Ona-oni-attene	(Represented by a Fish)
Sac-co-ni-binne	(Represented by an Elk) Charles Campeau
Minguinan	(Represented by a Bear) Henemargintemond
Nana-onite	(Represented by a Beaver)

In presence of the undersigned witness, Mr. Pierre Labady has signed his ordinary mark by a cross, the present contract countenanced.

PIERRE DeCOMPT DE LABADY

The characters used with the signature were drawn upside down designating that the animal or fish had been killed.

14

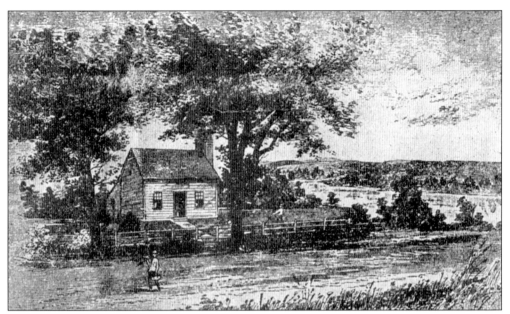

This is a depiction of the cabin built by Francois Navarre on the banks of the River Raisin. In 1780, seventeen-year-old Francois arrived in the Monroe area on horseback from Detroit. Navarre is considered to be the first permanent white settler in the region. For at least 100 years before the arrival of Navarre, French woodsmen had traveled the woods and rivers, trading with the Native Americans and French missionaries at trading posts in the territory. Francois Navarre's land was located on the south side of the river where the present-day Sawyer Homestead stands.

When Francois Navarre arrived on the banks of the River Raisin, he brought with him pear trees from his grandfather's Detroit farm. Over time, nearly every settler in the area had some pear trees, which grew to a height of 80 to 120 feet and yielded 30 to 50 bushels of fruit.

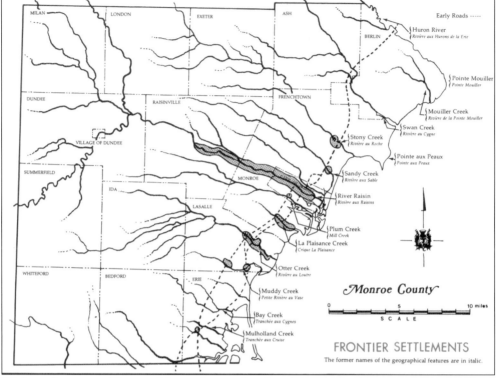

Monroe County

FRONTIER SETTLEMENTS

The former names of the geographical features are in italic.

Within a few years of Francois Navarre's arrival and settlement near the River Raisin, hundreds of French settlers made their way south from Detroit to avoid increasing British harassment and to enjoy the benefits of a number of rivers in what is today known as Monroe County.

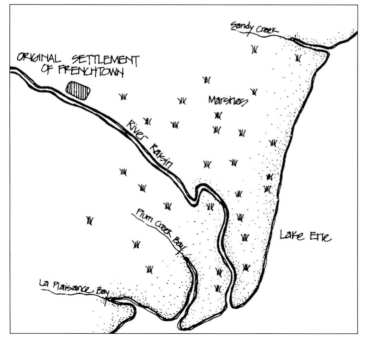

The Potawatomi generously gave up more land around the River Raisin to families of French settlers who followed Francois Navarre. A settlement called Frenchtown was built on the north bank of the River Raisin, 200 yards northeast of the present Winchester Street Bridge. The new settlers and the Native Americans got along well together. Many of the Potawatomi converted to the Catholic faith and it was not uncommon for the French settlers to take Potawatomi brides.

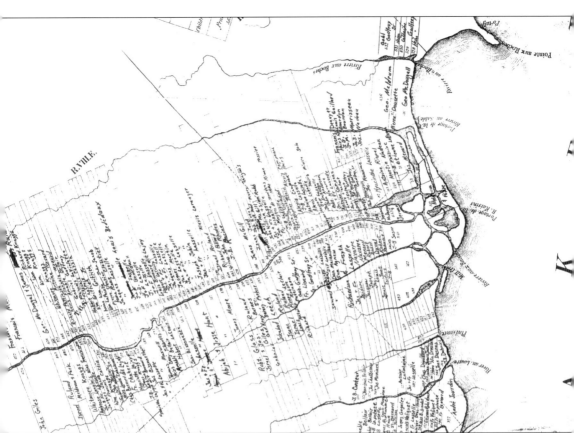

The French settlers built their log cabins close together along both banks of the river. The reason for this was the belief in a system of farming called ribbon farms. Only a small portion of the land from each farm fronted the river, while the rest of the farm extended into the forest, sometimes miles deep, giving each settler access to the river. This map shows the location of these early farms. To this day, the farms along the River Raisin are long and narrow. The houses were enclosed in palisades made with split logs driven into the ground. Much like the Native Americans, the French liked to hunt, fish, and trap. The river and marsh areas provided all they needed in terms of food and clothing.

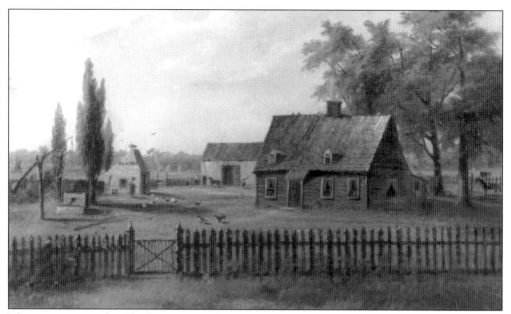

This is a painting by Charles Lanman depicting his birthplace along the River Raisin. It was based on what he remembered of its appearance as of 1819. The architecture reflects the hand of Francois Lasselle, who owned the farm before Mr. Lanman's family. Francois Lasselle was one of the early French settlers who came to the area with his family to set down roots. The painting is owned by Mrs. Pemberton Frame.

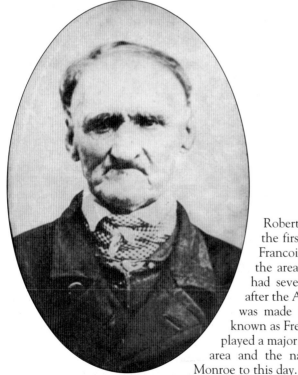

Robert Navarre, pictured here, was the son of the first permanent white settler in the area, Francois Navarre. A few years after arriving in the area, Francois married Marie Suzor. They had seven sons and five daughters. Not long after the Americans won independence, Francois was made the commander of the village (then known as Frenchtown) militia. The Navarre family played a major role in the settling and building of the area and the name Navarre is still well known in Monroe to this day.

Two

THE WAR OF 1812

"REMEMBER THE RIVER RAISIN"

For years, the British had stopped United States' ships, removing American sailors and forcing them to work on British ships. As settlers moved west into the Northwest Territory, uprisings by Native Americans caused constant worry and impeded the settling of new lands. Americans blamed the British for stirring up the Indian uprisings. The great Indian chief Tecumseh believed that this was the last chance Native Americans would have to keep white men out of their hunting grounds and he went about trying to unify Native American tribes to resist. In June of 1812, the United States declared war on Great Britain over the violations. The war would soon come to Frenchtown—and little did anyone know what a pivotal role this area would play.

By the time the War of 1812 broke out, the Frenchtown settlement on the north bank of the Raisin River had grown to consist of about 20 buildings surrounded by a puncheon fence. The settlement was repeatedly raided by Indians. People in the area feared for their lives and many fled. A local militia had been organized a few years before, commanded by Colonel John Anderson, and after war officially began, they expected an attack at any time. They were shocked when a British officer arrived on August 17 with news that General Hull had surrendered Detroit and given orders for them to surrender. In November of 1812, a small detachment of Canadian militiamen set up camp at Frenchtown. By this time, a new American army had been recruited in Kentucky with the elderly Revolutionary War veteran General James Winchester in command. On their way north, they were met by messengers from the River Raisin pleading for rescue. Over 600 men were dispatched and they arrived south of the River Raisin on January 18, 1813. The Americans were reinforced with 100 men from the River Raisin. They faced 63 Canadian militiamen and 200 Potawatomi Indians who were quickly driven into the woods a mile north of the settlement. The fighting continued until dark with the Americans winning at a cost of 13 killed and 54 wounded. The British and Indians retreated north to Brownstown.

The Americans set up camp among homes on the north side of the river. General Winchester arrived with reinforcements several days later, bringing the number of American troops to 934. On the morning of January 22, 1813, 597 British soldiers and 800 Indians used six cannon to launch a counterattack. The fighting raged for 20 minutes when the U.S. Seventeenth Infantry was flanked by Canadian militia and Indians. Orders were given to retreat to the river and make a stand, but this attempt was disastrous. Of the 400 Americans

who ran, nearly 220 were killed, and around 147 including General Winchester, were captured. Only 33 escaped to safety.

At the same time, the left flank, composed of nearly 500 Kentucky militiamen, was fighting from behind a picket fence. They successfully repulsed three British frontal attacks and drove back the British cannon. They expected the British to ask for a truce, but instead, they were shocked to receive a message from General Winchester that advised surrender. The Kentuckians reluctantly surrendered after insisting that the American wounded be protected. The British withdrew hurriedly to Detroit, but many of the wounded Americans were left behind in the homes of settlers due to the lack of sleighs to transport them. On the morning of January 23, all of the British guards left, but many of the Indians returned to the River Raisin. They plundered homes and wounded soldiers for valuables, and then killed and scalped all Americans who could not walk. Those able to walk were claimed by the Indians and taken to Detroit where they were ransomed. Over 60 unarmed American wounded were killed. This event was dubbed the "Massacre of the River Raisin."

Americans rallied and the battle cry throughout the rest of the war became "Remember the Raisin!" Volunteers seeking revenge flocked to recruiting stations after learning about the battles and slaughter of the injured Americans. These additions to the U.S. Army would help drive the British Army into Ontario. Meanwhile, Frenchtown was left a desolate, nearly abandoned settlement for eight months following the massacre. American dead were unburied and many homes were burned and plundered. Most settlers fled to Detroit or Ohio. The River Raisin was liberated on September 27, 1813, when Colonel Richard M. Johnson's Kentucky cavalry, led by men from the River Raisin, rode into the settlement. The Kentuckians pushed the British and Indians deep into Canada and decisively defeated them at the Battle of the Thames on October 5, 1813. Combined with the decisive naval victory by Commodore Oliver Hazard Perry at the Battle of Lake Erie, this defeat of the British ended the Northwest Campaign of the War of 1812. The destruction on the River Raisin was so severe that the settlement remained impoverished for five years, but now that the fear of the Indians and British in the Northwest Territory was gone, people from the East began to move West in greater numbers for new land and new opportunity. The area around the River Raisin would not be destitute for long.

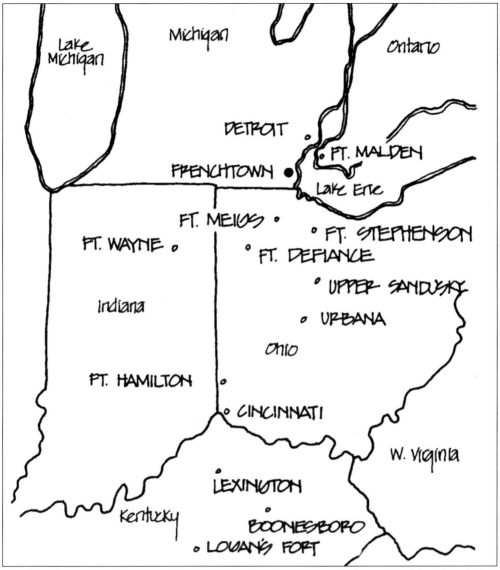

The River Raisin was the scene of events crucial to the course and aftermath of the War of 1812 in the Old Northwest and western Great Lakes country. The battles and massacre of January, 1813, first delayed and then made inevitable the final American victory and undisputed possession of the territory, eliminating the decades-old threat of the British and their Indian allies to the region. Strategically, the battle of January 22, 1813 altered the course of the war in the Old Northwest. The loss of one-third of his army in one battle—the single most costly for the United States during the entire war—forced General William Henry Harrison to abandon his winter offensive against Detroit and Fort Malden, Ontario, and retreat to a defensive position at Fort Meigs on the Maumee River in Ohio. But the victory proved a costly one for the British as well, leaving them unable to drive Harrison from the Great Lakes country. More importantly, the massacre of wounded American prisoners on January 23 galvanized the western settlements. Huge numbers of volunteers flocked to the recruiting stations seeking revenge. With substantial additions to his force, Harrison forced the British and Indians from northwestern Ohio and back across the River Raisin.

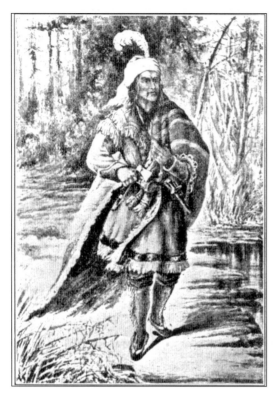

In 1806, Native Americans in the Northwest Territory started to show signs of dissatisfaction as Americans started to move further west. It was around this time that the Shawnee Chief Tecumseh (depicted in the drawing) came into prominence. The British made an attempt to organize lake tribes into a confederacy against the Americans. Tecumseh believed this was the last chance to keep the white men out of their hunting grounds and he helped organize tribes in the area and encouraged them to raid white settlements, including Frenchtown.

Hubert LaCroix came to the Monroe area in 1800 and was the first man to enlist in the militia organized by Colonel John Anderson for the purpose of defending the area from Indian attacks. He was unanimously chosen captain of the company in which he enlisted, in which capacity he continued until the commencement of the War of 1812. At the surrender of Detroit by General Hull, Captain LaCroix was taken prisoner by the British and for some time kept on board a prison-ship at Fort Malden. By the persistent efforts of an Indian trader, he was released and returned to the River Raisin.

By 1812, the Frenchtown settlement consisted of approximately 20 buildings surrounded by a puncheon fence. The small settlement found itself between the British army based in Detroit and American forces from the Kentucky volunteer militia led by William Henry Harrison. General William Hull built a road to Detroit through the community as the first step in a projected American campaign to wrestle Canada from the British. Hull had left a small detachment at Frenchtown to secure his supply route. That small force, including a locally recruited unit of the Michigan militia, erected a small fortification, Wayne Stockade, on the north bank of the river about one mile west of the main part of the settlement near the present intersection of Elm and Monroe Streets. When Hull surrendered Detroit, the articles of surrender included the forces at Frenchtown. On January 18, 1813, the Kentucky militia attacked and sent the British retreating. Four days later, the British counterattacked and repelled the Americans south. More than 300 Americans died during the British counterattack, the single most deadly battle for the United States during the war. Early the following morning, large numbers of Indians who had fought with the British left Frenchtown in ruins, and killed 60 to 65 of the wounded Kentuckians. This map shows the logistics of the battles.

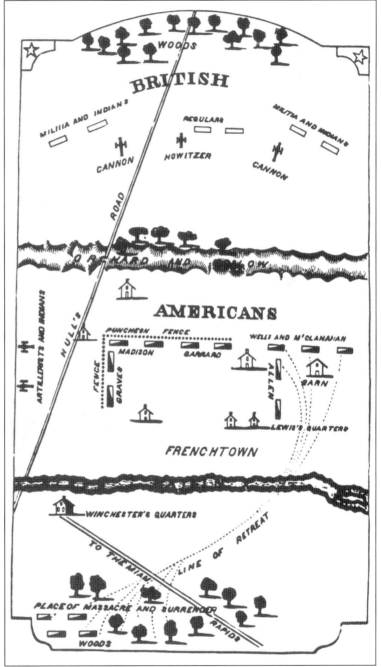

23

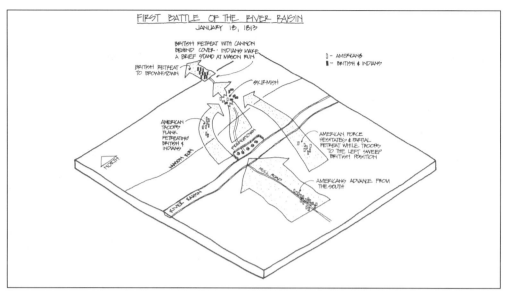

On January 17, 1813, 660 Americans were sent toward Frenchtown. The next afternoon, finding about 75 Essex militiamen and about 200 Indians waiting for them in the fenced area at the eastern end of Frenchtown, the Americans formed a line and advanced against the enemy. The British and Indians withdrew to the northeast and set up a harassing fire against the American right, who at this time were in Frenchtown on the north side of the river. A series of advances and retreats took place until dark, when the Americans withdrew into the fenced area of Frenchtown and the British and Indians withdrew northeast to Brownstown.

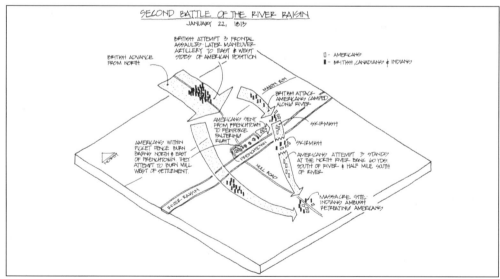

Learning that the Americans had spread out throughout Frenchtown, a group of British regulars and First Nation's warriors made for Frenchtown across the frozen river. The British and their Indian allies surprised the Americans at dawn on January 22, 1813. They quickly crushed the American right flank and General Winchester surrendered his entire army. The British retreated back to Brownstown and left some of the American wounded under First Nation's guard. The next morning, warriors executed about 60 Americans and the incident soon became known in American newspapers as "The River Raisin Massacre."

24

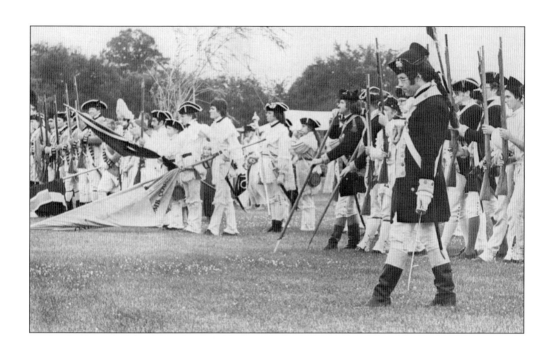

News of the British victory on the River Raisin spread quickly to England. Published in London, this print (below) depicts General Winchester being brought to Colonel Proctor by the Indians at Fort Malden, Amherstburg, Ontario. The second Battle of the River Raisin was the most serious disaster to befall an American army during the war. Of 934 soldiers present at the start of the action, 495 were prisoners of Proctor's force, and 406 were dead, missing, or held prisoner by the Indians. Only 33 men escaped. The above image depicts a River Raisin Battle reenactment.

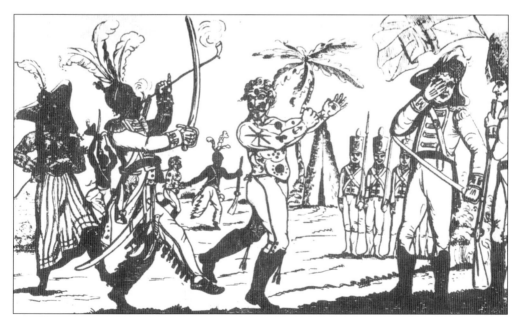

This structure was built by Samuel Navarre, son of Colonel Francois Navarre, in about 1810. It was used to house the wounded after the Battle of the River Raisin in 1813. When British Colonel Proctor left Frenchtown, the American and British wounded were taken on sleighs. There were not enough sleighs to transport all of the wounded Americans and many were left behind under the guard of First Nation's warriors.

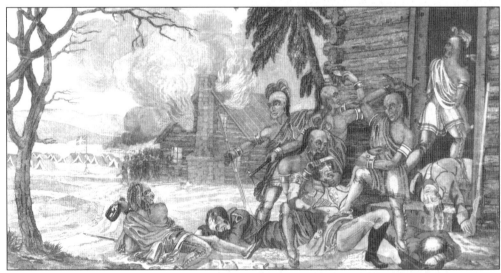

This is a depiction of the massacre at Frenchtown that took place on January 23, 1813. Left in Frenchtown after the battles were 60 to 65 wounded Americans, mainly Kentucky volunteers. Large numbers of Indians concentrated around the buildings where the wounded were housed. By mid-morning, they engaged in a systematic campaign of plunder and murder, going from building to building, killing in various ways those unable to walk, and looting and burning the structures. Prisoners healthy enough to walk were stripped and taken to Detroit for ransom; those who faltered were killed en route. Frenchtown was left in ruins and 60 to 65 Kentuckians were dead.

General James Winchester was an elderly Revolutionary War veteran from Tennessee who was placed in command of the Kentucky volunteers. He was ordered to hold at Miami Rapids (Maumee, Ohio) until General William Henry Harrison's entire army was assembled and ready to advance. Before Harrison could arrive with the main body, Winchester received runners from Frenchtown reporting that a small British force, with a large store of supplies, was there. In addition, the general feared for the safety of Frenchtown's people. Recognizing that he would be exposing his force and defying orders, he nevertheless decided to move. Winchester's mismanagement of his force led to the eventual surrender of his army and his capture. (Courtesy Tennessee State Museum.)

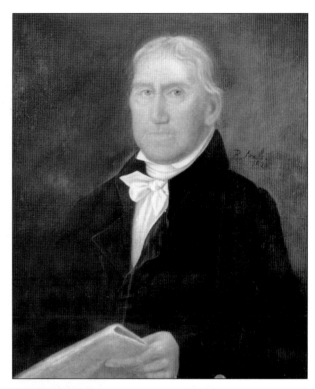

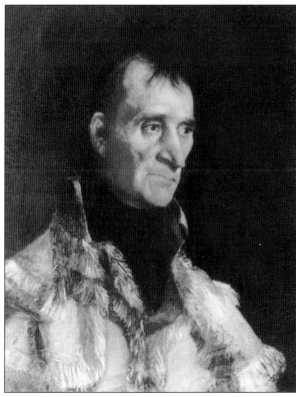

Major Bland W. Ballard (1759–1854) led the American charge at the First Battle of the River Raisin. This picture shows him dressed in his rifle buckskin frock, just as he would have been in the battle.

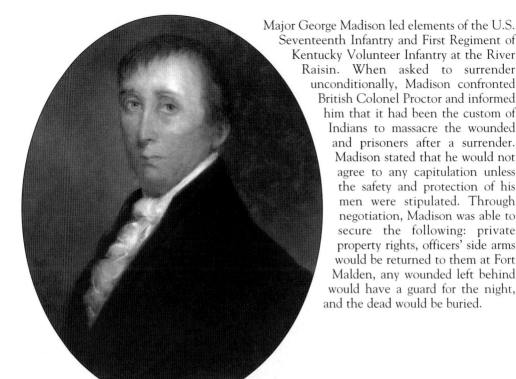

Major George Madison led elements of the U.S. Seventeenth Infantry and First Regiment of Kentucky Volunteer Infantry at the River Raisin. When asked to surrender unconditionally, Madison confronted British Colonel Proctor and informed him that it had been the custom of Indians to massacre the wounded and prisoners after a surrender. Madison stated that he would not agree to any capitulation unless the safety and protection of his men were stipulated. Through negotiation, Madison was able to secure the following: private property rights, officers' side arms would be returned to them at Fort Malden, any wounded left behind would have a guard for the night, and the dead would be buried.

General William Henry Harrison (1773–1841) commanded the American army in the Northwest Territory during the War of 1812. He defeated a large band of Tecumseh's warriors at the Battle of Tippecanoe. After the Massacre of the River Raisin, the few who escaped made their way to warn General Harrison. Many who lived on the Raisin, including many French, cast their lot with Harrison. Harrison thought so much of these men that he once exclaimed: "River Raisin men . . . the best troops in the world." Throughout the rest of the war, residents of the River Raisin kept General Harrison informed of the movements of the enemy. When General Harrison defeated the British at the River Thames, the War of 1812 in the Northwest was essentially at an end. Because of his service in the War of 1812, Harrison became a national hero and was elected the ninth President of the United States. (Courtesy Library of Congress.)

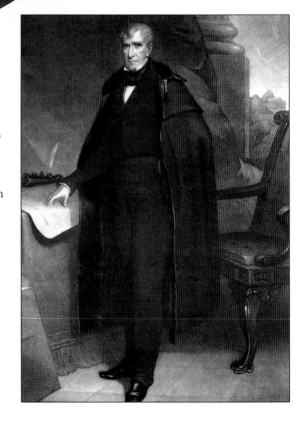

Peter Navarre (1787–1874), known as "noble scout," was a familiar figure in the Monroe and Toledo region. Engaged as a trader for the American and Northwest Fur Company, Peter was renowned for his courage and daring. During the War of 1812, he was captured, paroled, and reentered the service. Peter and his cousin Francois, as well as 36 Navarres, served the United States valiantly during the War of 1812. British General Henry Proctor offered £200 for Peter's head or scalp. Peter was serving with General Winchester when the American forces were slaughtered at the River Raisin. He managed to escape across the frozen lake. One of his duties during the war was to carry dispatches. In September of 1813, Peter Navarre made a perilous trip on foot to carry a message from General William Henry Harrison from Fort Meigs to Commander Oliver Hazard Parry at Put-In-Bay advising him to engage the enemy as soon as possible. Upon returning to the Maumee River, he carried back Perry's now famous message which read, "We have met the enemy and they are ours." When Peter returned to his home at Presque Isle, he carried with him the gun which General Harrison had given to him (shown in the portrait). In this portrait, Peter is seen wearing a knitted cap adorned with feathers, a favorite French form of headgear, in his belt is a hatchet, and a powder horn is slung over his shoulder.

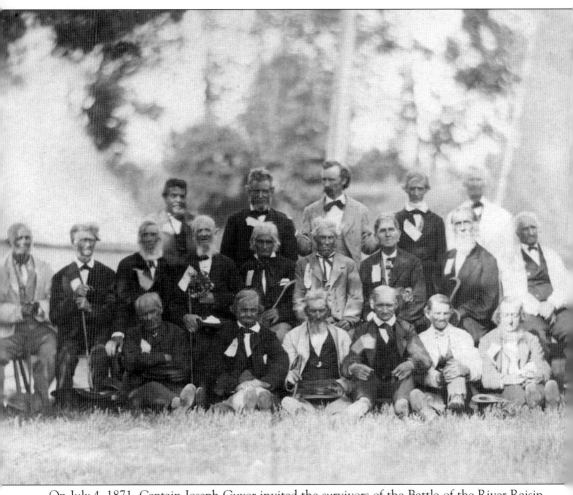

On July 4, 1871, Captain Joseph Guyor invited the survivors of the Battle of the River Raisin to a dinner at his home on Guyor's Island, two miles east of Monroe. The oldest veteran to attend was over 100 years of age. The gathering was addressed by Mayor H.J. Redfield and General George A. Custer, I.R. Grosvenor, and Colonel Luce. During the reunion, the War of 1812 veterans posed for a picture with General George A. Custer. Pictured from left to right are the following: (bottom row) Peter Navarre, age 82; James B. Nadeau, age 77; Emmanuel Custer; Robert F. Navarre, age 80; Joseph Foulke, age 80; and Bronson French, age 82; (center row) Joseph B. Beseau, age 80, George Younglove, age 96; John Buroff; David Van Pelt; Lewis Jacobs; Charles Hivon, age 76; Henry Mason, age 79; Thomas Whelphy, age 73; and Joseph Guyor, age 88; (top row) John Bezeau; John Clapper, age 76; General George A. Custer; Francis Navarre, age 82; and Jean Chauvin, age 77.

Three

THE SETTLING AND BUILDING OF MONROE

With the United States victorious in the War of 1812, there was an increased feeling of safety that motivated settlers to move to the western frontier. The land around the River Raisin was enticing: it was great for farming, it was inexpensive as the government looked to encourage settlement, and water and food were plentiful for humans and livestock. At first, the influx of settlers was slow because the area was difficult to reach. After loading everything that a wagon could carry, traveling with livestock was rough through mountains and on treacherous, sometimes muddy, and often impassible roads. It was during this time period that the area received the name it bears today. To honor President James Monroe's service and the first U.S. President to visit the Northwest Territory, on July 14, 1817, Michigan Governor Lewis Cass named a newly created county in Southeast Michigan, Monroe County. Two months later, the township of Monroe was established.

The completion of the Erie Canal in 1825 made the trip to the frontier much easier. Westbound pioneers could now ride up the Hudson River, through the Erie Canal to Buffalo, across Lake Erie by steamboat or sailboat to LaPlaisance Harbor. From there, a dirt road, which was eventually turned into a plank road, led to the settlement on the River Raisin. The Erie Canal reduced a once 5-to-10-day arduous land journey to a 44-hour water route. From the end of the War of 1812 to 1837, the area was not only rebuilt, but grew to an estimated population of 1,500. Many of the new homes built were of brick and most new settlers chose the south side of the river because French settlers owned most of the land on the north side. Wanting to establish a town with its own local government, settlers were unable to agree on whether the town should be on the north side, where the main settlement of Frenchtown had been started, or on the south side, where most of the new settlers had built their homes. Joseph Loranger, an early settler, had operated a store on the south side of the river before the war, and he offered to donate the land needed for streets, a courthouse, and a public square.

The old military road built by General Hull was improved for use by stagecoaches and local settlers. A regular stagecoach service was started in 1826 to carry mail and passengers; it made a stop in Monroe twice a week. Among the settlers that made their way to Monroe were many tradesmen and professionals who would help in building the area up: farmers, storekeepers, mill operators, lawyers, physicians, school teachers, preachers, blacksmiths, and others. The River Raisin provided water power from several dams for much-needed gristmills. Other important industries were started, including a tannery, where skins of cows and horses were made into

leather for shoes and harnesses. In the downtown area, there was a distillery and sawmill. There were also brickyards and asheries, where wood was burned to make ash for soap. Ice was cut in the winter to keep meat fresh in the summer. A land office was set up where settlers could examine maps for available land, pick out a desired region, and then purchase parcels from the government for $1.25 per acre. The early pioneers had quite a task to establish a farm in an area of dense forests with the limited tools they possessed: an ax, a hoe, a plow, and a harrow. First, the trees needed to be cut and cleared. In building a cabin, logs had to be fashioned by hand. Then the grubs were dug out, the land plowed and harrowed, and rows planted. The times were filled with hard work and a hope to build a better life.

In 1835, work began on what would be called the United States Canal in order to connect the River Raisin directly to Lake Erie. In 1843, a 1,300-foot City Canal was completed, which connected to the United States Canal. The Port of Monroe now became the point of entry for settlement and commerce. In 1837, the Michigan Legislature appropriated money for the construction of three railroads that would cross the state from east to west. The Michigan Southern Railroad was the southernmost of the three railroads and it connected Monroe to New Buffalo on the eastern shore of Lake Michigan.

An intense rivalry developed between the settlers of the Michigan Territory and the state of Ohio, and in 1835, a controversy over a strip of land almost boiled over into full scale war between the two. Monroe found itself right in the middle of the controversy. Original U.S. surveys placed the mouth of the Maumee River, around which Toledo was forming, in Monroe County. When Ohio started construction on the Miami Canal, it obtained from Congress a new survey that showed this area to be part of Ohio. Months of arguing on both sides ensued; Ohio partisans were seized in the contested area and tried in the Monroe County Courthouse. Militia from both Michigan and Ohio rushed to the border, but no fighting broke out. The "Toledo War" ended with Michigan accepting the Upper Peninsula in exchange for the Toledo strip, and with the admission of Michigan to statehood in 1837.

In the years before the Civil War, Monroe was not able to keep pace with the cities of Detroit and Toledo in terms of population and development into a commercial center. Instead, Monroe was developing a uniqueness that was matched by few other areas. A big part of that uniqueness derived from a reputation that Monroe developed as the "Floral City." It started with the establishment of the first nursery in 1841 by Eliab H. Reynolds. Bought out by Israel Epley Ilgenfritz, the business continued to grow until Mr. Ilgenfritz was called "Nursery King of the State." Other nurseries were established, which created an entire industry in which Monroe was the leader.

An account was set down by a citizen who lived through these early years, and the description gives a sense of what Monroe was like in the years before the Civil War came calling:

> Indeed, Monroe resembles some New England village. An aire of refinement, wealth, and culture pervades the city. Flowers and fruit are grown in profusion, and about every house we see grounds in the highest state of cultivation that the soil will admit. Apart from the elegant private residences, there are a number of public edifices worthy of note—among them the Courthouse, a structure of hewn stone costing some $30,000, the schools among which are the Young Ladies Seminary and the Union School, are highly tasteful in architecture, and the beauty of their grounds.

When war did come, it would not only change Monroe forever, but the entire country as well.

Captain Hubert LaCroix served in the American army during the War of 1812. At the surrender of Detroit, he was taken prisoner by the British. During the River Raisin battles, his residence was reduced to virtually nothing. Upon his release and return to the area, LaCroix and Edward Loranger built this two-story brick structure on the north bank of the River Raisin. It was built in 1817–1818. It was eventually purchased by Louis LaFountain. Known as the "Block House," it stood east of the Shoreline Railroad on the site of the River Raisin Paper Company.

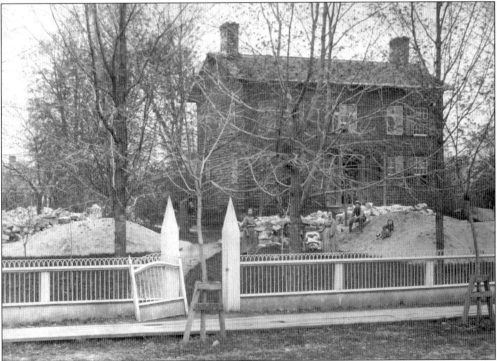

This is the first home of Dr. Alfred Sawyer as it appeared c. 1870. The house was built by Colonel Francois Navarre, the first permanent white settler to the Monroe area. The original log cabin that stood on the premises served as the headquarters of General Winchester during the River Raisin battles. The cabin was clapboarded by Dr. Sawyer when he took possession, and then torn down to make way for Dr. Sawyer's new home, which was built for his bride. That home still stands today on 320 East Front Street.

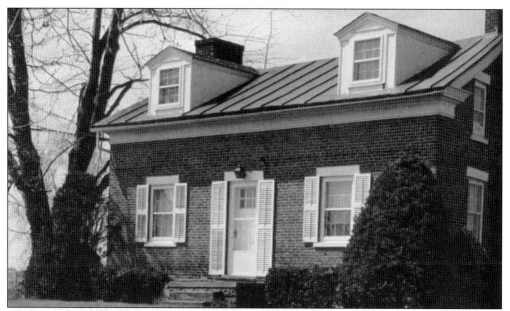

Edward Loranger, a brick mason from Trois Riveres, Canada, built this house around 1825. The house, with a basement kitchen, interior walls of brick between posts, and symmetrical one-and-a-half story façade, is typical of early French houses. The home was built on South Stony Creek Road in Frenchtown Township and is still standing today. Loranger was instrumental in developing the area, as many of the businesses were built under his supervision. He operated a much-needed gristmill in the area which provided the essential processing of a farmer's crops into usable products. Loranger's gristmill was eventually moved to Greenfield Village, Henry Ford's historical village in Dearborn, Michigan.

Around 1823, Colonel Oliver Johnson, merchant, financier, and civic leader, built this home on First Street on the southeast corner of Loranger Square. Five generations of the Johnson-Phinney family lived in it before it was sold in 1960 to Monroe County. One of the rare Federal-era homes left in Michigan, it was modified in 1869 by adding Carpenter-Gothic gables and a high roof. The Monroe County Historical Society and the City of Monroe moved it to its present location at West Second and Cass Streets in 1977.

Mr. Gottfried was born in Germany on February 25, 1828, and came to America with his parents in 1847. The family came directly to the village of Monroe where he worked as gardener and then as a teamster. In 1849, he took employment on the Michigan Southern Railroad, and after showing his ability, he was promoted to the position of foreman. For 16 years, he was thus employed at a salary of $1.25 a day. He managed to save enough to buy a farm west of Monroe in 1865, and he developed it into what was considered to be one of the best farms in Monroe County.

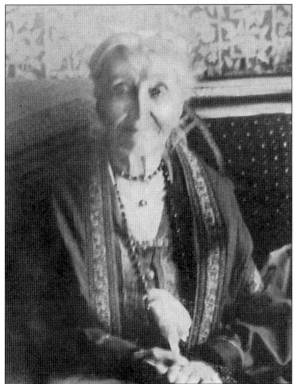

Mrs. Sarah Conant Hogarth was born on February 3, 1832. Her father, Harry Conant, settled in Monroe in 1825 and their home, which was the first brick home built on the south side of the river, was completed a year or two before she was born. She was educated in the McQueen School and the Young Ladies Seminary, each of which her father was instrumental in founding. On November 19, 1864, she married John P. Hogarth who was in business in New York and they resided there until 1870, when they returned to Monroe. She was an active member of the Presbyterian Church and took great interest in the growth and development of Monroe.

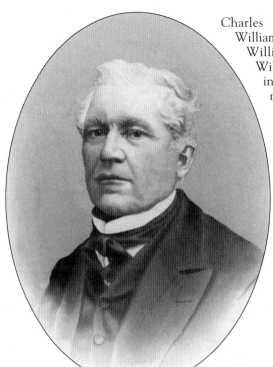

Charles Noble (1797–1874) was born in Williamstown, Massachusetts. He graduated from Williams College and practiced law in Williamstown. He arrived on the River Raisin in 1820. Throughout his career, he held a number of public offices: register of deeds, district attorney, postmaster, Indian agent, member of the general assembly, member of the legislative council, president judge of the county court, and surveyor general. He was a man of deep religious convictions, and in 1831, he became a member of the First Presbyterian Church. For a number of years, he served as a ruling elder there.

Austin E. Wing was born in Conway, Massachusetts, in 1792. He graduated from Williams College and entered the law office of William Woodbridge in Marietta, Ohio. When Woodbridge moved to the Michigan Territory, Wing followed and they again operated a law office, this time in Detroit. He served as sheriff of the Territory for a number of years and became a representative of Monroe County in Congress. His son, Talcott E. Wing, was an attorney and counselor in Monroe and wrote and published a history of the area from the early settlement to the year 1890. Austin Wing built and occupied a stately mansion on the north side of the River Raisin.

Construction was started in 1838 on a city canal for the purpose of cutting off a sharp horseshoe bend in the river and thus permitting larger vessels to reach the docks. It was completed in 1843. From that time to the present, frequent dredging at certain points in the channel has been necessary to keep it clear and of sufficient depth for navigation. The canal is 1,300 feet long. In August of 1838, property owners voted overwhelmingly in favor of securing a loan to finance the project. To pay for construction, the City of Monroe issued $25,000 in bonds which were to be paid in 20 years. The City Canal initially had a depth of 11 feet. Throughout its history, the Port of Monroe has seen shipments of armor stone, asphalt cement, coal, limestone, lumber, industrial equipment, petroleum coke, sand, and Renault cars. Monroe is Michigan's only Lake Erie commercial port.

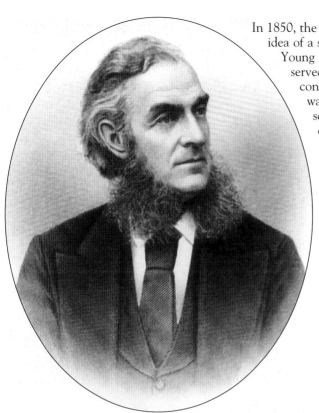

In 1850, the Reverend E.J. Boyd conceived the idea of a seminary for girls and founded the Young Ladies' Seminary of Monroe. He served as principal and the institution continued in operation until 1883. It was long recognized as an excellent school and women from every area of the United States were educated there. Many of these women gained prominence throughout the country.

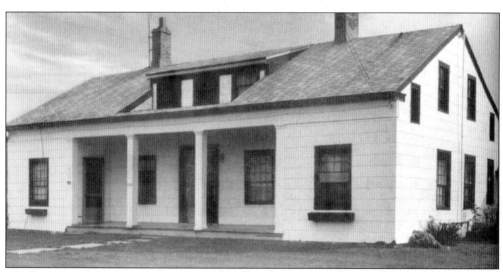

This house was built in 1838 by Joseph G. Navarre, fourth son of Colonel Francois Navarre. He studied for the priesthood for seven years, but before completing his studies, he entered the law office of Honorable William Woodbridge of Detroit. While in the office of Governor Woodbridge, he was called home by the illness and death of his father. He settled on a farm south of Monroe. Joseph did not enter upon professional life as a lawyer, yet was very frequently consulted by the early settlers on all questions pertaining to the titles to their lands, their claims for losses in the War of 1812, and the settlement of controversies that arose on the River Raisin.

Peter Navarre (1787–1874), the famous scout, was a familiar figure in the Monroe and Toledo regions. He was a cousin of Colonel Francois Navarre. Peter engaged in trading furs for the American and Northwest Fur Companies. He was described by many of his contemporaries as a very handsome man with courtly manners, engaging and charming in conversation. He served valiantly in the War of 1812 as a scout. He settled on the Maumee River and had six sons and two daughters. According to historical accounts, he was dearly loved by many in Monroe and northern Ohio and helped build the foundation for the region.

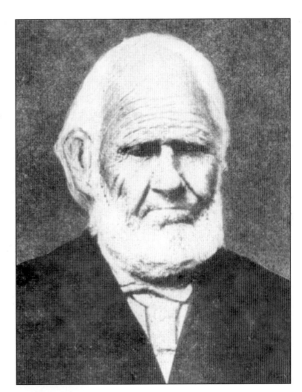

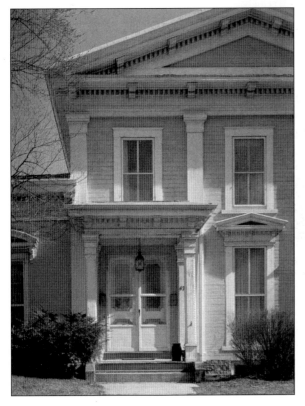

Robert McClelland, state legislator, member of Congress, governor of Michigan, mayor of Monroe, and President Pierce's secretary of the interior, was the most prominent occupant of this house. He operated a law office in the area for a number of years. The structure was built in 1835–1836 by Ebenezer Howes. The home is listed on the National Register of Historic Places. It is located on East Elm Street.

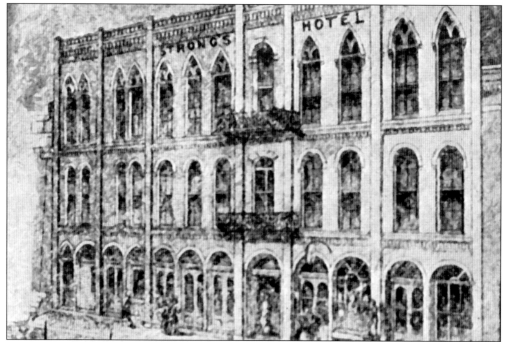

Strong's Hotel was built by George W. Strong in 1859. In 1868, Monroe suffered her most disastrous visitation of fire, which destroyed nearly all the buildings in the half block west of Washington Street between Front and First streets, including Strong's Hotel. Strong was also a captain of water vessels and he built and operated a steamer, called the Water Witch, which operated between LaPlaisance Bay Harbor and the docks. He operated flat-bottom steamers to carry light cargo from larger boats to shallow draft boats. Strong built a sloop, the *Revenge*, which had a 35-ton capacity and operated as a grain carrier to and from Canadian ports.

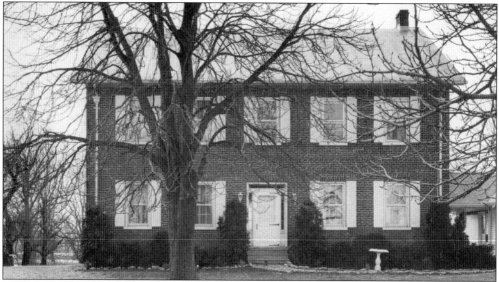

The Seitz Hotel was built in the late 1850s as a stagecoach stop on the plank road between Monroe and Cambridge Junction. The dances and social affairs that were held at the hotel were legendary in the county. The building still exists today on North Custer Road.

Conway P. Wing was born near Marietta, Ohio, on February 12, 1809. He graduated from Hamilton College in 1828 and from Auburn Theological Seminary in 1831. He was pastor of the First Presbyterian Church in Monroe from 1838 to 1842 and was very zealous in his opposition to slavery. He was a great scholar and was highly thought of by his parishioners. Wing translated *A History of the Christian Church* from German into English and he published a number of works on Presbyterian Church history.

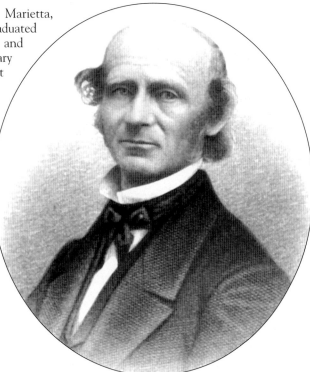

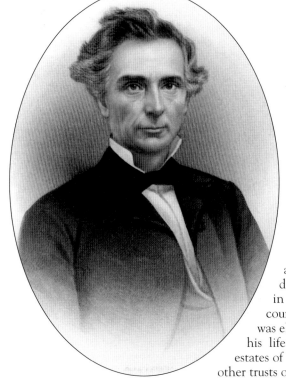

Alfred G. Bates (1810–1864) was born in Canandaigua, New York, in 1810. He moved to a farm on the River Raisin in 1834 and married Betsey Ann Elliot, with whom he had 12 children. Two years after his arrival, he was elected sheriff of Monroe County, and was later appointed deputy U.S. marshal of the district of Michigan. He played a major role in breaking up well-organized bands of counterfeiters and horse thieves. In 1852, he was elected to the Michigan legislature. During his life, he was engaged in the settlement of estates of deceased friends and neighbors and many other trusts of importance.

Restome R. Kirby came to Michigan with his parents in 1836 when he was six years old. In September of 1853, he enrolled in the Buffalo Medical College, receiving the degree of Doctor of Medicine in 1854. He began to practice medicine in Monroe County, devoting himself to the duties of his profession until the spring of 1861, when he received an appointment as a surgeon in the Union army. He was transferred to cavalry duty, later rising to the rank of captain. In January of 1865, suffering from nervous fever caused by wounds sustained while in the United States service, and having contracted rheumatism from previous exposure in 1864, he drew up his resignation and returned to Monroe County to resume his medical practice.

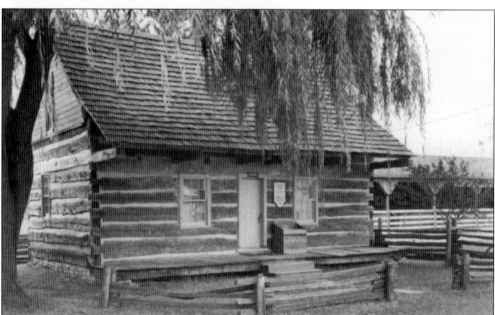

Johannes Eby built this log cabin in 1857 following Germanic architectural customs. Eleven children were born and raised in the cabin by John (son of Johannes) and Elizabeth Eby. The children used a lofted area as sleeping quarters. The walls were made of handhewn logs, sometimes 12 inches square. Straw, sand, and unslaked lime were used to weatherproof the structure. Once located on Stewart Road in Maybee, it was moved to the Monroe County Fairgrounds by the Monroe County Historical Society in 1960 and is presently used for history-related educational programs.

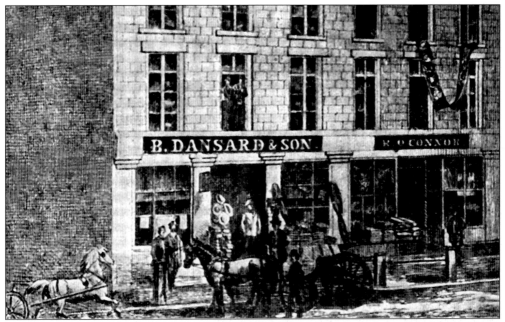

In 1836, Benjamin Dansard came to Monroe and entered the mercantile business. In 1858, seeing the need for a banking institution in Monroe, he formed a co-partnership with Louis Lafountain and opened a bank in back of his store, which was located on the site of the Finzel Hardware Store (this would become E. Stadelman Furniture Store). Success brought a need to grow and he purchased the building at the corner of Washington and Front Streets. He disposed of his mercantile business and devoted all his time to building up the bank. He took his son Joseph into partnership, hence the name B. Dansard and Son Bank.

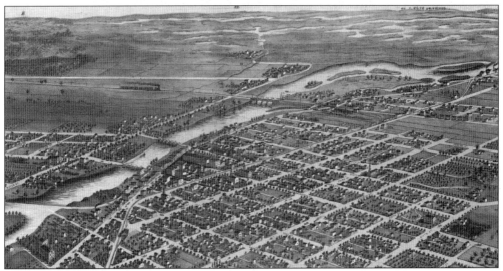

This map, which was drawn and published in 1866, provides a bird's-eye view of what Monroe looked like at that time. The map was indexed for points of interest which included the following: the German Catholic Church; the French Catholic Church; the Episcopal Church; the Lutheran churches St. Zion, St. Trinity, and St. Emmanuel; the Presbyterian Church; the Methodist Church; the Union School; the Young Ladies Seminary;and the courthouse, jail, and battlefield.

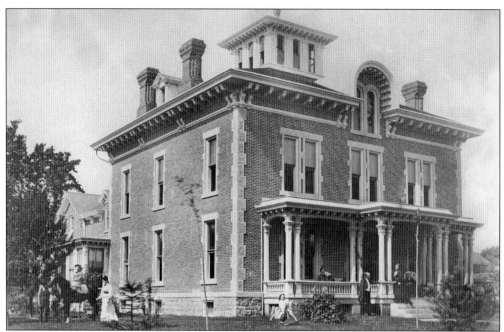

The land on which the Sawyer House sits was the site of the home of Francois Navarre, the first permanent white settler on the River Raisin. The land was acquired from the Potowatomi Indians in 1785 and served as a center for the early River Raisin settlement. General Winchester made the Navarre home his military headquarters prior to the Battle of the River Raisin in 1813. Dr. Alfred I. Sawyer and his family lived there from 1859 until 1870 when it was demolished to make room for the structure in this image. This picture was taken in 1875.

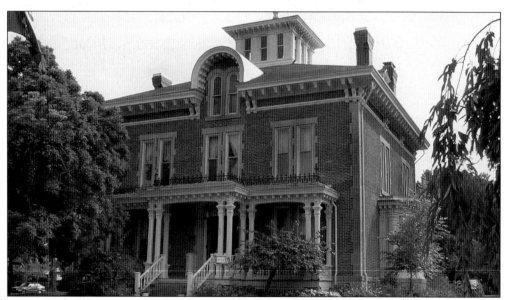

The charming Italiante house was completed in 1873. Dr. Sawyer was one of the early proponents of homeopathy as the correct philosophy of medicine. He was an American delegate to the International Homeopathic Congress in London in 1881 and was elected president of the National Institute of Homeopathy in 1889.

Edward George Joseph Lauer was born February 20, 1859, in Monroe. At the age of 14, he started working at a dry goods store for $7 a month and board. After having learned the dry goods business through a nine-year clerkship, he started his own dry goods emporium in Monroe. He gave his customers a selection of goods as large and varied as any store of its kind in Toledo or Detroit. Mr. Lauer believed in treating his customers well, and no matter who came into his store, rich or poor, they were always shown the same attention.

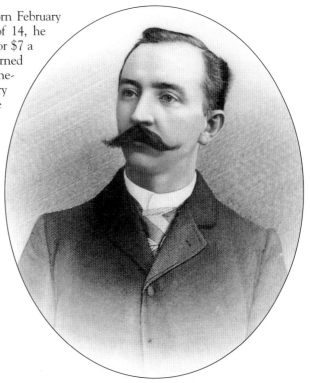

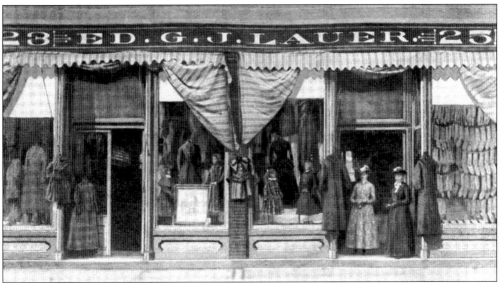

Customers always found Mr. Lauer and his clerks pleasant, affable, and courteous. This attention to the customer helped the business to thrive to the point where there was a need to expand. Mr. Lauer believed in giving his clerks an interest beyond their regular salary, and he adopted a plan of giving them a percentage of the profits as compensation for faithful service. Lauer dealt directly with trade centers and made several trips to New York each year which enabled him to take advantage of markets that others did not, thus providing his customers the greatest variety of products.

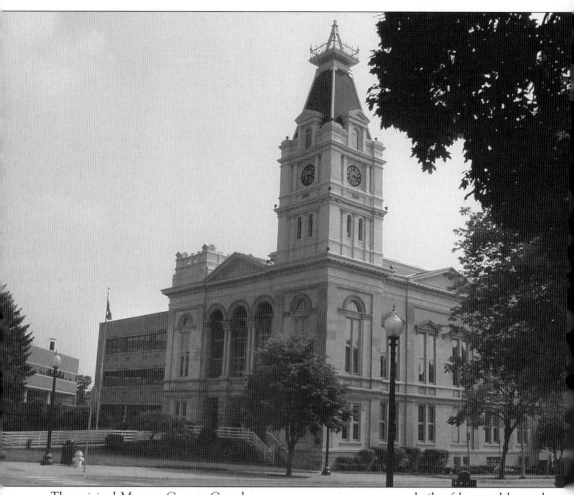

The original Monroe County Courthouse was a two-story structure built of logs and located across the street from the present courthouse at the current site of the Presbyterian Church. It housed not only the court, but also the jail and the jailer's quarters, and served in this capacity from 1818 to 1839. A new stone courthouse was constructed in 1839 on the site of the present courthouse. It served Monroe County until 1879 when it was destroyed by fire. Some of the partially-burned records, and some records dating back to 1856 which are still legible and are used for historical facts, remain in the county clerk's office. The present courthouse was built in 1880 and there have been three additions throughout its history. During the early morning hours of April 13, 1992, an arsonist set fire to the Monroe County Courthouse, causing extensive damage to the probate court, the historic circuit courthouse, the treasurer's office, and the main entrance. The restoration and remodeling took 10 months to complete.

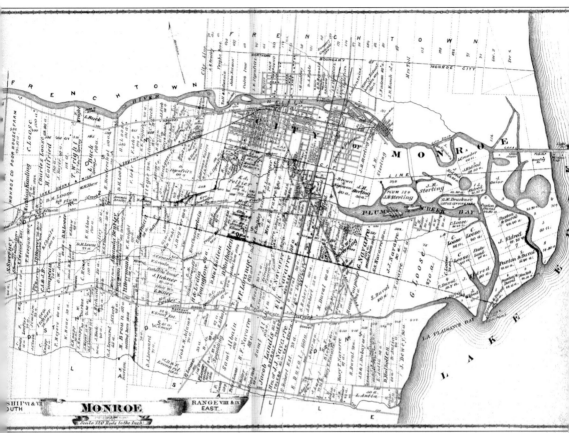

This is a map of Monroe drawn in 1876. There had been a steady growth in population from the time of the construction of the Erie Canal until the 1880s. With the opening of the Flint and Pere Marquette Railroad, the business interests of Monroe and the surrounding region were given a boost. There was now access to the lumbering regions and a market for hay and grain. Easier access to the towns along the shores of Lake Huron furnished a ready outlet for berries, vegetables, and fruits, and the market for nurseries began a steady growth. Nurseries eventually became one of the most prominent industries in Monroe. The actual number of retail outlets in Monroe's central business district reached a high point in the late 1870s and early 1880s. In an account written in 1883 from his recollections, I.P. Christiancy commented on living in Monroe: "I must still say of Monroe that it is yet one of the pleasantest towns for residence in the State. A large portion of her people are among the most intellectual to be found in the State, educated and refined. The town is embowered with trees, and fruits and flowers abound perhaps more than in any other town of the State, and her suburbs are embellished with the richest vineyards. Taken all together, I know no pleasanter place to live in for those who wish to pass a quiet life."

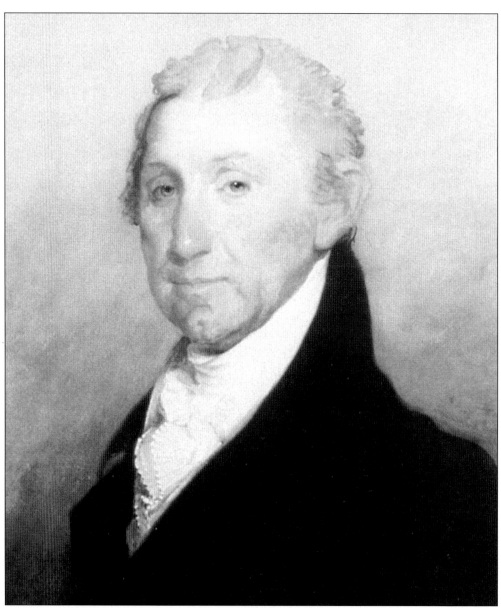

On July 14, 1817, Governor Lewis Cass established Monroe County; two months later, he established the township of Monroe. An area that had been known as Nummaseepee, River Raisin, and Frenchtown would now bear the name of the fifth President of the United States, James Monroe (pictured above). The name was given to honor the first U.S. President to visit the Northwest Territory and for his great service in helping the area to recover from the devastation caused by the War of 1812. In the summer of 1817, President Monroe made a trip through the Northwest Territory and made a stop in Detroit. James Monroe served as both Secretary of State and Secretary of War during the War of 1812. This portrait was painted in 1817. During his presidency, from 1817 to 1825, he tried to follow the example set by George Washington, keeping himself above partisan politics. By the end of his term in office, however, Monroe worried that he had done little to be remembered in history. Of course, in Monroe, Michigan, he will always be remembered.

Four

THE CIVIL WAR
COMES CALLING

When news of the firing of Confederate guns on Fort Sumter reached Monroe in April of 1861, the area answered the call. No county in the nation had a larger number of volunteers, proportionately, than did Monroe County. With President Abraham Lincoln's call for troops, a meeting of Monroe citizens was held at the Humphrey House. The next evening, the courthouse was jammed with Monroe citizens who pledged their all for the Union. From this meeting, a committee was appointed to organize a local military company and another to solicit funds for the cause. Cheered on by a band, this company left for Camp William in Adrian, Michigan, on May 29, 1861. Ironically, the color of their uniforms was West Point gray, which was chosen to be the color for the Confederate army. They became Company A of the Fourth Michigan Regiment, were sworn into service on June 21, and shortly thereafter left for Washington. At the beginning of August, the Seventh Michigan Regiment came to Monroe to form an encampment and drill. Company D of the Seventh Michigan was recruited locally. The Fifteenth, Seventeenth, Eighteenth, and Twenty-fourth Infantries also included Monroe men.

Ira R. Grosvenor of Monroe became the first commander of the Seventh Michigan Infantry. He had already acquired experience as an officer of an independent military company and had been a brigadier general of the state militia. Although he signed on to command the Seventh for three years, a case of scurvy would cut short his term. On September 5, 1861, the 884 officers and men of the Seventh Michigan Regiment left Monroe to join the Army of the Potomac. Chaplain A.K. Strong, a local Presbyterian minister, kept Monroe well informed of the activities of the Seventh. The regiment took part in the following battles: Ball's Bluff, Yorktown, Fair Oaks, Peach Orchard, Savage Station, White Oak Swamp, Glendale, Malvern Hill, and Manassas. The regiment was complimented by commanding generals on numerous occasions for its steadiness under fire, its gallantry in action and its stubborn resistance when confronting the Confederate forces. Colonel Norman J. Hall of Monroe County became the commander in July of 1862 and led the Regiment at the Battle of Antietam, where its ranks were decimated by nearly one-half. The Seventh gained a reputation for valor when the regiment volunteered to cross the Rappahannock River in pontoon boats while under enemy fire in order to drive Confederate soldiers from cover. At Gettysburg, the regiment was assigned a position on Cemetery Ridge, and maintained that position till the end of the battle. The Seventh was at the Siege of Petersburg, and was marching when the surrender of the Army of Northern Virginia at Appomattox Courthouse occurred on April 9, 1865. Of the 1,375 enlisted

in the 7th Michigan throughout the war, 127 were killed in action, 56 died of wounds, 147 died of disease, 17 died in Confederate prisons, and 344 were discharged for wounds.

When Company A left Monroe to join the Fourth Michigan Regiment, the women of the area prepared lint, bandages, undergarments, and fatigue shirts. They also presented the company with a silk flag. The battle at Newbridge on May 24, 1862 gave the Fourth Michigan Regiment national recognition. A staggering loss for the Confederacy, Monroe Company A played a crucial role by launching a surprise attack on the flank of the Confederate troops. Charles Gruner of the Fourth Michigan Regiment drew sketches of major battles the regiment took part in, and the fighting that he was able to capture was lithographed for various publications. Two Monroe men from the Fourth Michigan Regiment, Samuel Ladder and George Yates, were part of the Union balloon service which was used for reconnaissance. Colonel George Spalding, a Monroe teacher before the war, became one of the country's finest Civil War soldiers. By the end of the war, he had been promoted to brigadier general.

The Fifteenth Michigan Infantry was organized at Monroe under the command of Colonel John M. Oliver. The Fifteenth took part in the battle of Pittsburgh Landing, the Seige of Corinth, Vicksburg, Hayne's Bluff, Jackson, and the Georgia Campaign including the Seige of Atlanta, Jonesboro, and Savannah. Of the 2,390 enlisted in the Fifteenth Michigan throughout the war, 51 were killed in action, 24 died of wounds, 4 died in Confederate prisons, 182 died of disease, and 286 were discharged for wounds. Monroe County residents fought and died in every major battle of the Civil War. Even at the infamous Andersonville Prison Camp in Georgia, 21 Monroe men died of disease.

When hostilities started, both sides believed the war would be over quickly, but the conflict dragged on for four long years. Bull Run, Shiloh, Antietam, Fredericksburg, Gettysburg, Atlanta, Vicksburg, and Richmond were on the lips of every family as news of devastating losses of life reached Monroe. Lee's surrender at Appomattox brought peace of mind to Monroe and the rest of the country. Interestingly, the war had accomplished something for a son of Monroe who would become one of the most infamous cavalry commanders in history. George Armstrong Custer became one of the best-known and most capable Union commanders during the Civil War. After the war ended, the way was paved for his army career, which would conclude in infamy.

John Morrison Oliver joined the Union army as a private on April 17, 1861. He served in the Fourth Michigan Infantry where he was promoted to captain. Oliver was appointed Colonel in the Fifteenth Michigan Regiment on September 25th, 1861. He was involved in the following battles or campaigns: Shiloh, Corinth, Vicksburg, Atlanta, and the March to the Sea with General Sherman. Colonel Oliver was promoted to brigadier general on January 11, 1865.

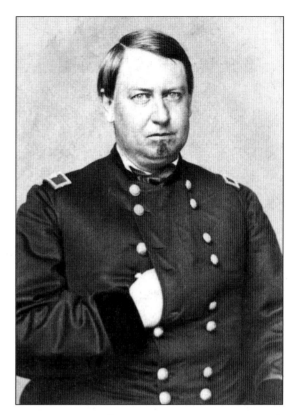

Andrew Guyor, known as Kibbie, is pictured here at the age of 27. He enlisted in Company A of the Fourth Michigan Infantry on May 16, 1861. He was discharged for disability at Harrison's Bar, Virginia, on July 10, 1862. He was a member of the Monroe Grand Army of the Republic (GAR) Post and is buried in St. Joseph Cemetery.

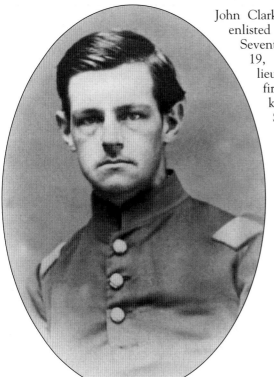

John Clark was born in 1841 in Monroe. Clark enlisted in Company D as a sergeant in the Seventh Michigan Volunteer Infantry on June 19, 1861. He was commissioned a second lieutenant on March 18, 1862, and then a first lieutenant one month later. Clark was killed at Antietam, Maryland, on September 17, 1862. Fellow soldiers buried him where he fell. A few weeks later, his family arrived and arranged for his body to be brought home and interred in the family plot at Woodland Cemetery.

Charles Gruner was born in Austria in 1837. He enlisted in Company C of the Fourth Michigan Infantry as a first sergeant on May 16, 1861. He was wounded at Fredericksburg and Spotsylvania. Gruner was discharged as a first lieutenant at Washington D.C. for wounds received on June 19, 1864 at Petersburg, Virginia. In his application for Monroe's GAR Post, he described his wound as being caused by a rifle ball that went through both hips from left to right. After the war, he was a painter in Monroe and lived on East Cass Street. He died in 1912 and was buried in Woodland Cemetery.

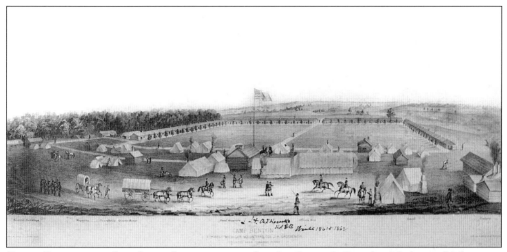

Camp Benton was the place of encampment for the Seventh Regular Michigan Volunteers under Colonel Grosvenor. Pictured here from left to right are hospital buildings, magazine, guardhouse, quartermaster, and headquarters. The facility, located on the outskirts of St. Louis, could hold 30,000 soldiers and contained a mile of barracks, warehouses, cavalry stables, parade grounds, and a large military hospital. The hospital itself could house 2,000 to 3,000 patients. New regiments were organized and mustered into service here. Troops were instructed in marching and drill techniques in preparation for deployment. The camp also served as an encampment for paroled federal prisoners of war.

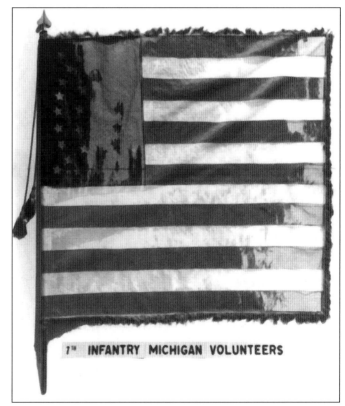

This is the battle flag of the Seventh Michigan Infantry. The flag is stored at the State Museum in Lansing. The regiment, mustered into service on August 22, 1861, in Monroe, fought in numerous major engagements: Fredericksburg, Gettysburg, Second Bull Run, Antietam, the Wilderness, and the Siege of Petersburg.

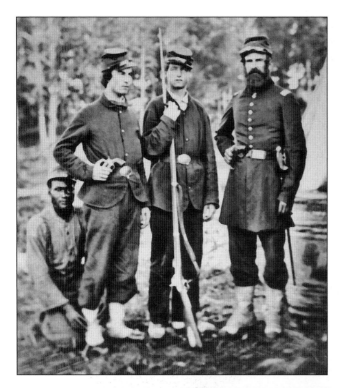

Senter S. Parker enlisted in Company H of the Fourth Michigan Infantry as a sergeant on June 20, 1861. He became the regimental commissary sergeant on September 1, 1861. Parker was commissioned as a second lieutenant over Company B of the Fourth Michigan Infantry on July 26, 1864. Pictured here on the far right when he was a commissary officer, Parker resigned on January 31, 1865.

George W. LaPointe, enlisted in Company D as a Corporal on June 19, 1861, at the age of 19. He was promoted to sergeant, second lieutenant, and first lieutenant, then becoming captain of Company C on September 21, 1863. LaPointe was wounded at Spotsylvania, Virginia, on May 13, 1864. He was promoted to Lieutenant Colonel and mustered out as such on July 5, 1865 at Jeffersonville, Indiana.

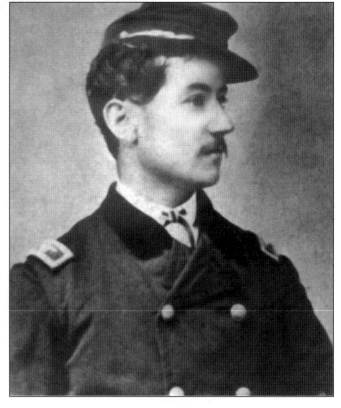

G.B. DeLong was born in Monroe in 1825. He enlisted in Company E on July 25, 1862, as a Sergeant, at the age of 37. He was discharged for disability at Falmouth, Virginia, on November 24, 1862. DeLong was very active in the Monroe GAR Post. He died on September 24, 1897 and was buried in St. Joseph Cemetery.

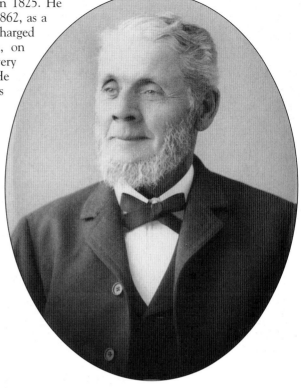

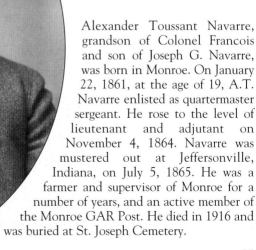

Alexander Toussant Navarre, grandson of Colonel Francois and son of Joseph G. Navarre, was born in Monroe. On January 22, 1861, at the age of 19, A.T. Navarre enlisted as quartermaster sergeant. He rose to the level of lieutenant and adjutant on November 4, 1864. Navarre was mustered out at Jeffersonville, Indiana, on July 5, 1865. He was a farmer and supervisor of Monroe for a number of years, and an active member of the Monroe GAR Post. He died in 1916 and was buried at St. Joseph Cemetery.

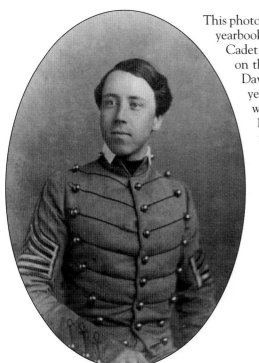

This photograph of Norman J. Hall is from the 1859 class yearbook of West Point. He entered the West Point Cadet Military Academy on July 1, 1854 at age 17 on the appointment of Secretary of War Jefferson Davis. The class of 1857 was the first to have a yearbook, simply a collection of photographs with signatures from their birth state. The year 1859 marked the first five-year class at the military academy. Norman Hall became a brevet second lieutenant of the Fourth Artillery on July 1, 1859.

Norman Hall was the sole Michigander to witness the official start of the Civil War at Fort Sumter. He served on General George McClellan's staff during the Peninsular Campaign and was promoted to Colonel of the Seventh Michigan Volunteer Infantry. He fought at Antietam, Fredericksburg, and Gettysburg before being honorably discharged because of disability. Hall never recovered from service-related disabilities brought on by a sickness acquired in Charleston, South Carolina. He died on May 26, 1867. Norman J. Hall was buried at West Point and his grave is very close to Generals Robert Anderson, Winfield Scott, and another well-known Monroe son, George A. Custer.

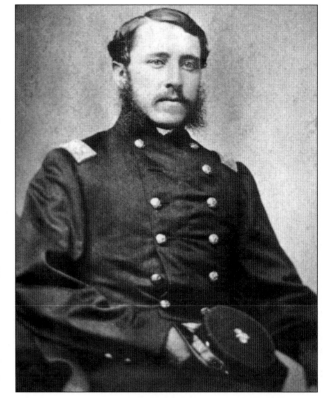

George Owen enlisted on June 20, 1861 at the age of 21. He served throughout the entire war. Originally from Monroe and later serving as editor of the *Shiawasee American*, he wrote a letter in 1887 about his experience in the Civil War, stating: "To have served our country during the rebellion was a great privilege and honor . . . the best loved companions of my life were my comrades of the Smith Guard, better known as Company A, 4th Michigan Infantry. And it was my lot to see them drop out one after another, by sickness and in battle—while I was spared to pass through all."

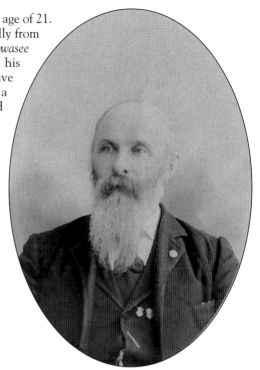

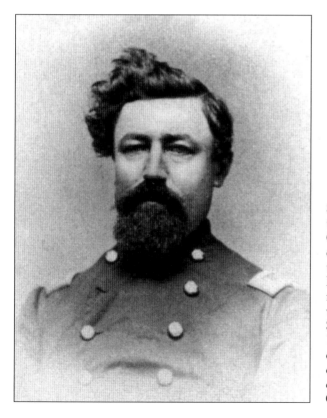

Sylvanus W. Curtis is pictured at the age of 30 when he enlisted in Company D as a first lieutenant on June 19, 1861. He became the captain of Company H on March 1, 1862, and major of the regiment the next year. Curtis was wounded in action at Spotsylvania, Virginia, on May 10, 1864. He was discharged at the expiration of his term of service on October 5, 1864. Curtis was a charter member of the Monroe GAR Post. He died in 1895.

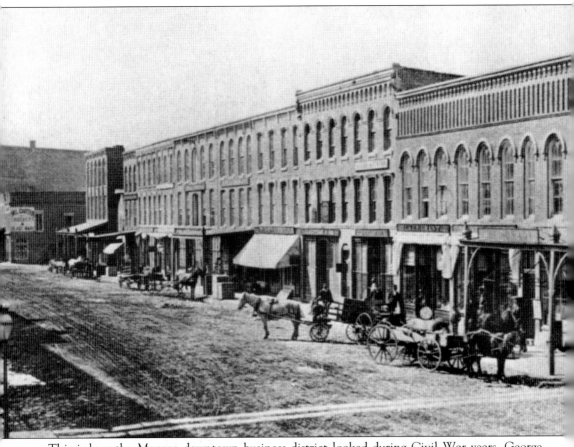

This is how the Monroe downtown business district looked during Civil War years. George Armstrong Custer enjoyed galloping down the boardwalk in the block beyond on busy days. Initially, the war seemed to have an adverse effect on the Monroe economy. In July of 1861, food prices were at their lowest throughout the war. There was little demand for wheat and no buyers for wool since it was not of the coarse grade required for Army uniforms. Business did not generally improve until 1863 when agricultural prosperity arrived in the North. This fact is suggested by a letter in the private collection of the late Mrs. George R. Navarre from L.H. Cooper dated April 10, 1862, which related: "The weather is very wet and cold as yet. Nothing doing, business very dull in Monroe. My store is almost ready, but I will not try to open until harvest time as there is no money in the country. And I do not wish to trust out my stock." Because of wartime demand, times had changed by 1864 and 1865. These boom years were accompanied by the joys and problems of an inflationary economy.

George Spalding is pictured here at age 24. He was mustered in Company A on June 20, 1861 and became the first lieutenant of Company B on August 15, 1861. He was wounded in action on July 1, 1862 at Malvern Hill. Spalding resigned on July 18, 1862 and then reenlisted as lieutenant colonel of Eighteenth Michigan Infantry. Spalding served as provost marshall from June 14, 1863 to January, 1864. He resigned to accept promotion to colonel of Twelfth Cavalry on February 21, 1864 and then he was promoted to brigadier general on March 21, 1865 for valuable service in the battle of Nashville. Spalding was honorably discharged on October 24, 1865.

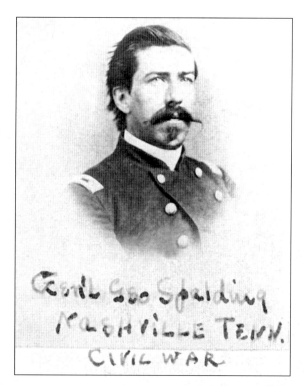

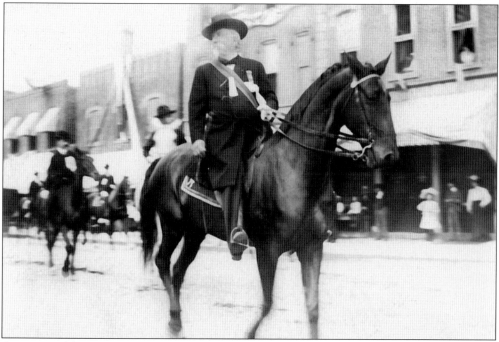

George Spalding is pictured here as part of a procession in a veterans' parade in 1904. He joined Monroe's GAR Post in 1883, and was active in many civic organizations in Monroe, including serving as mayor and postmaster. He died on September 13, 1915 and was buried in Woodland Cemetery.

The Grand Army of the Republic (GAR) is pictured marching in a parade in front of Finzel Hardware.

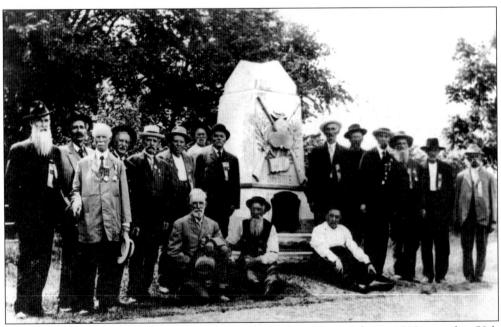

This photograph was taken at Gettysburg, Pennsylvania, on July 3, 1913, on the 50th anniversary of the famous battle. In the picture are members of the Seventh Michigan Regiment at the place where they had fought 50 years before. They are gathered around the monument erected in honor of the Seventh Michigan Regiment.

This is the Fourth Michigan Regiment Monument at Gettysburg. It is located in the Wheatfield, where on July 2, 1863, some of the bravest soldiers of the Civil War died. Among them were men from of the Fourth Michigan Regiment of Monroe County whose bodies now are in the Gettysburg National Cemetery two miles away from the monument. The representation on the front of the monument is Colonel Harrison H. Jeffords, who was killed while defending the colors of the Fourth Michigan Infantry.

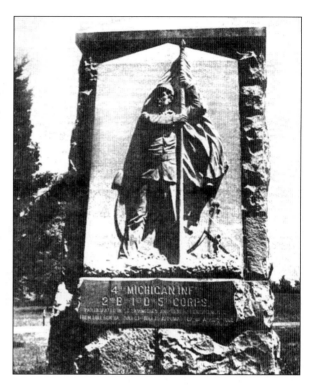

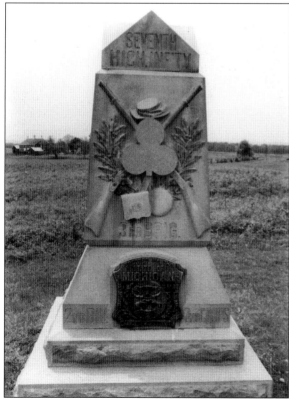

Pictured is the memorial to the Seventh Michigan Infantry at Gettysburg. The Regiment was mustered at Monroe and was composed of companies from all over Michigan including the "Monroe Light Guard." At Gettysburg, 21 men of the Seventh Michigan were killed and 44 wounded. In all, there are 10 monuments standing to the 4,000 Michiganders who fought at Gettysburg.

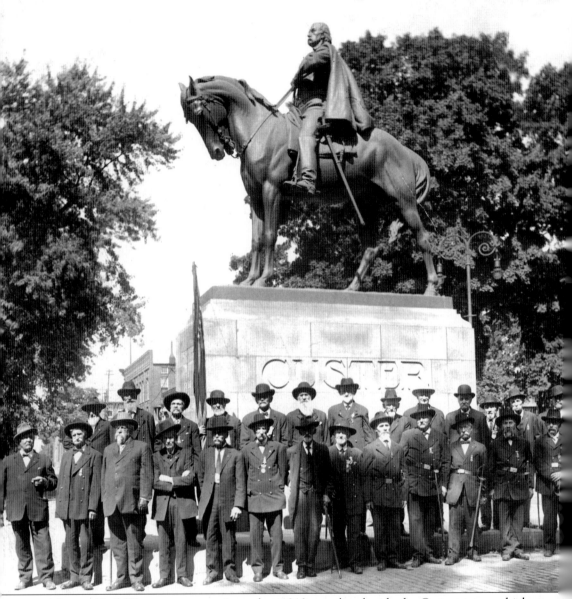

Monroe Civil War veterans are pictured, c. 1910, standing beside the Custer statue, which at that time stood at the intersection of East First and Washington Streets. Those identified are as follows, from left to right: (front row) A.J. Navarre, Adolph Rupp, General George Spalding, Sherman, Justus Sorter, Levi Wagner, Joe Sturn, George Kirschner, Adam Michael, Bernard Sturn, A. Lehr, unidentified, and unidentified; (back row) third from left is Leonard Mitchell, eighth from left is Levant Webb, and the rest in the back row are unidentified.

Five

GEORGE ARMSTRONG CUSTER

George Armstrong Custer was born in New Rumley, Ohio, on December 5, 1839. He first came to Monroe when he was 10 years old to attend the New Dublin primary school. At the age of 14, George Custer attended the Stebbins Academy. His father, Emanuel, was a farmer and a blacksmith. In helping his father out with both endeavors, Custer developed a love of horses. Another major interest he had at an early age was reading military novels, and he made up his mind early on to go to West Point Military Academy. During his years in Monroe, he met Elizabeth (Libbie) Bacon. Although from very different backgrounds at the time of their first meeting, they fell in love. Their relationship blossomed into a great romance, but one major obstacle stood in the way of their being married. Her father, the prominent Judge Daniel Bacon, was opposed to their relationship because Custer was a soldier and he feared his daughter would be left a young widow.

After graduating from West Point in June of 1861, Custer was assigned to duty as a lieutenant in the Fifth Cavalry and participated in the First Battle of Bull Run. General Philip Kearny selected Custer as his first aide-de-camp, and then he served on the staff of General William F. Smith as a balloonist—he made ascensions in balloons for the purpose of reconnaissance. General George B. McClellan was so impressed with Custer that he promoted him to the rank of captain in May of 1862. At Chickahominy, Captain Custer led an attack that surprised the enemy and drove them back, and as a result of this action, he and his men captured the first colors taken by the Army of the Potomac. On May 15, 1863, General Alfred Pleasonton appointed Custer as his aide-de-camp and for his daring gallantry at Brandy Station and Rappahannock. He was appointed brigadier-general of volunteers and assigned as commander of the Michigan Brigade.

At Gettysburg, General Custer and his brigade defeated General Jeb Stuart. For this, he was brevetted major on July 3, 1863. He was wounded at Culpepper Courthouse, but recovered to take part in General Sheridan's second raid on Richmond in which his Michigan Brigade made a gallant fight and the colors were saved by General Custer, who tore them from the pole and concealed the flag in his bosom. He assumed command of the Third Cavalry Division and at Cedar Creek his men recaptured guns and colors that had been taken earlier; they went on to capture Confederate flags and cannon. For this brilliant success, General Custer was sent to Washington and recommended for promotion. For gallant and meritorious services at Five Forks and Dinwiddie Courthouse, General Custer was brevetted brigadier-general on March 13,

1865. General Custer received the flag of truce from the Army of Northern Virginia and he was present at the Appomattox Courthouse for the surrender of General Robert E. Lee. General Custer and his men had certainly done their part to make this surrender happen. In a general order addressed to his troops on April 9, 1865, General Custer said:

> During the past six months, though in most instances confronted by superior numbers, you have captured from the enemy in open battle 111 pieces of field artillery, 65 battle flags, and upward of 10,000 prisoners of war, including seven general officers. Within the past ten days, and included in the above, you have captured 46 field pieces of artillery, and 37 battle flags. You have never lost a gun, never lost a color, and never been defeated; and, notwithstanding the numerous engagements in which you have borne a prominent part, including those memorable battles of Shenandoah, you have captured every piece of artillery which the enemy has dared to open upon you.

Perhaps Custer's greatest victory was in winning the heart of Libbie, and finally receiving her father's approval to marry. On February 9, 1864, they married at the First Presbyterian Church in Monroe. Their honeymoon was spent on the muddy soil of Virginia battlefields. Libbie accompanied her husband in his nine years of service on the western frontier, and she devoted her life to the preservation of his memory. In April of 1933, a few days before her 92nd birthday, Elizabeth Bacon Custer passed away. She was buried next to her husband at the West Point military cemetery.

On July 28, 1866, General Custer accepted the post of lieutenant-colonel of the Seventh Cavalry. He served on the plains until 1871. On November 27, he led a battle at Washita, in Indian Territory, and inflicted such a defeat on the Indians that the entire Cheyenne tribe was compelled to return to the reservation. He then accompanied an expedition to Yellowstone in 1873, and on August 4 of that year, he and his regiment fought the Sioux near the mouth of Tongue River. In July of 1874, General Custer led an expedition into the Black Hills for reconnaissance purposes. In May of 1876, General Custer accompanied an expedition against the confederated Sioux tribes, believed to be the nucleus of an Indian uprising. The Indians were discovered encamped on the Little Bighorn River and the number of warriors was in the area of 5,000. Custer and his men had no idea what they were up against. He and his men arrived at what they supposed to be the only Indian village on June 25, 1876. Custer led 262 United States Army cavalry soldiers and scouts into battle against an overwhelming force of Lakota Sioux, Cheyenne, and Arapaho tribes. General Custer and his entire command were slain. All of the officers and men were buried upon the battlefield, and in 1879 it was made into a national cemetery. A monument recording the names and rank of all who fell has been erected by the United States government on the battlefield. In 1877, General Custer's remains were moved to the cemetery at West Point. No cavalry officer in history has a superior record. His legacy will live on forever. On the 40th anniversary of the end of the Civil War, the *Monroe Democrat* published an account of General Custer's achievements. The last sentence read: "Well may Monroe be proud of the fact that he was once a son of hers and when a boy played in her streets."

George Armstrong Custer's Father, Emanuel, moved his family from New Rumley, Ohio, to Monroe in 1842. Shortly after arriving, his horses were stolen. Discouraged by this, the family returned to New Rumley. At the age of 10, George was sent to Monroe to live with his half-sister and to attend the Stebbins Academy. Years later, while in the army, George wanted his younger sister, Margaret, to have the advantages of the education that was possible in Monroe, so he persuaded his father to give Monroe another chance. In 1863, Emanuel Custer left Ohio for good and moved to Monroe with his family. Emanuel divided his time between farming and blacksmithing.

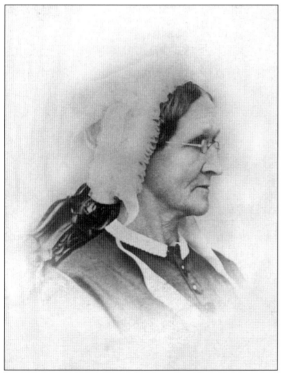

Emanuel married Maria Ward Kirkpatrick in 1836 and they had five children: George Armstrong, Nevin, Thomas, Boston, and Margaret. Maria was a loving soul and Autie (George Armstrong's nickname) was her favorite. She was born in Burgettstown, Pennsylvania, in 1807, and lost her husband at a young age, which left her alone with three children. One daughter from her first marriage, Lydia Ann, married David Reed of Monroe. George lived with the Reeds as a boy when he attended school in Monroe.

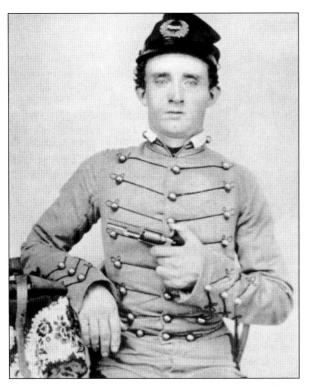

Cadet Custer grasps his Colt-Root model in 1859. George Custer received an appointment to West Point in 1857. He was not the best of students. In his war memoirs, he remarked: "My career as a cadet had but little to commend it to the study of those who came after me, unless as an example to be carefully avoided." He graduated near the bottom of his class. His last year at West Point, southern states began to secede from the Union and many southern cadets resigned from the Academy. The national crisis created an immediate need for men with military training. Upon graduation, Custer was at once commissioned a second lieutenant in Company G of the Second Cavalry, the regiment formerly commanded by Robert E. Lee.

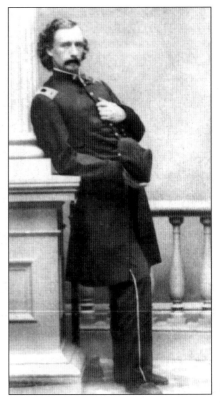

Captain George Armstrong Custer is pictured in April of 1863. He reported for duty the day before the Battle of Bull Run. By riding all night, he reached General McDowell's headquarters at daybreak and participated in that disastrous battle. He was one of the last to leave the field, leading his company in good order, and rescuing General Heintzelman, who had been wounded. He served throughout the Peninsular Campaign with the Army of the Potomac and participated in all the severe engagements of that memorable campaign. In an advance made by General Hancock, he captured the first battle flag taken by the Army of the Potomac, and at Chickahominy, leading a company of the Fourth Michigan, he was the first to cross the river. For this he was promoted to captain. This picture was taken in Monroe by William Bowlsby.

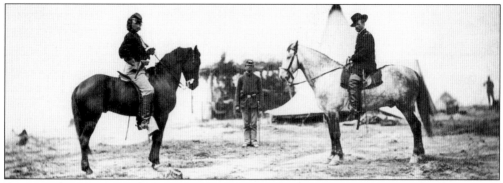

Custer and Major General Pleasington pose at Brandy Station, Virginia, in 1863, when Custer was 23 years old. When General McClelland retired from command of the army, Custer went with him, and for a short period was out of active service. He, however, was back on the battle front in time to take part in the Battle of Chancellorsville, and was made an aid to General Pleasanton, who commanded a division of cavalry. When Pleasanton was made a major general he recommended Custer for brigadier general, and he was appointed and placed at the head of the Michigan Fifth, Sixth, and Seventh Cavalry, constituting the famous Michigan Brigade.

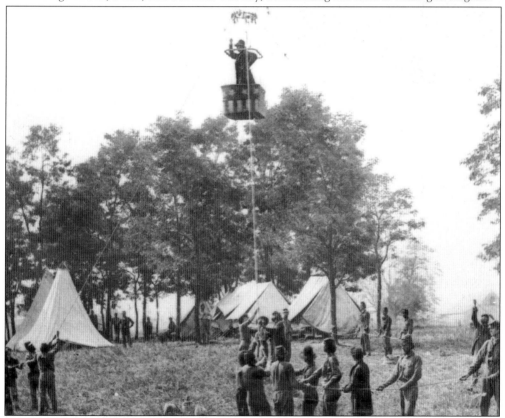

During the siege of Yorktown, General W.F. (Baldy) Smith ordered Lieutenant Custer to make daily ascensions and observations in a balloon. Civilian balloonists had provided unreliable reports. Because of poor visibility, Custer ascended at night to locate and count the enemy campfires. During the siege of Yorktown, he reported that the enemy had evacuated the town during the night.

Elizabeth Clift Bacon is pictured in 1862, prior to her marriage to George Armstrong Custer. When Custer was out of active duty for a short period, he went home to Monroe and it was during this time that he formally met the girl he was to later marry. Nearing her 20th birthday, she was considered the prettiest girl in Monroe. In early January of 1863, he was advised to stop visiting the Bacon home because Monroe was beginning to gossip and because Judge Bacon, her father, objected. Judge Bacon believed no good could come from marriage to a soldier.

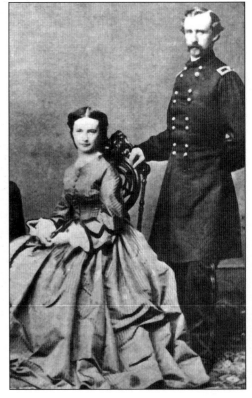

In the spring of 1863, George and Libbie made a pledge to one another, but she wanted no formal engagement until her father would give his consent freely. It was not Custer the man that her father was opposed to; he feared that his daughter might be left a young widow. It seems that patience was rewarded, because Libbie's father, Judge Bacon, finally gave his consent, and on February 9, 1864, the couple took their vows at the First Presbyterian Church in Monroe. Libbie's honeymoon was spent in the muddy soil near Virginia battlefields. This picture was taken shortly after their marriage, by Matthew Brady.

General Custer and Elizabeth (right) were phtographed in 1865 on the march north from Appomattox back to Monroe. The Civil War was officially over.

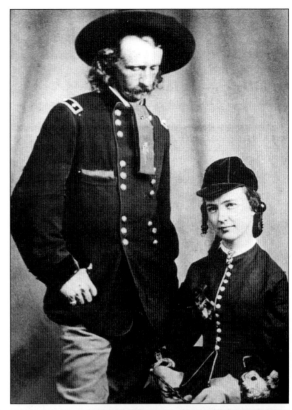

Elizabeth "Libbie" Clift Bacon was born in 1842 and raised in this house (below). Her father, Judge Daniel S. Bacon, was one of Monroe's most prominent citizens. The home, pictured here in 1868, was originally located at 126 South Monroe Street. After the Judge's death from cholera in 1866, the home served as a temporary residence for the Custers, and Libbie lived there for a time after her husband's death in 1876. In 1911, the house was moved to its present location on Cass Street, in order to provide space for the Monroe Post Office. It is now located at 703 Cass Street.

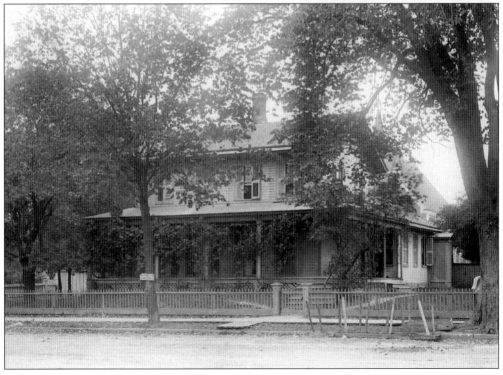

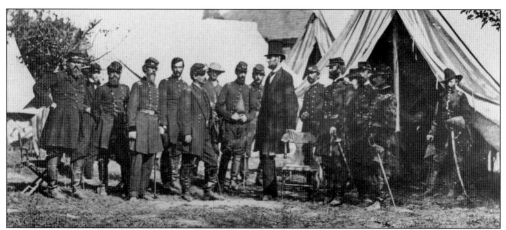

President Lincoln is pictured meeting with General McClellan's staff in 1862. Custer can be seen on the far right. This photograph was taken by Alexander Gardner on October 3, 1862. (Courtesy National Archives.)

Custer is the youngest general in this group of Civil War officers. They were considered the core of General Sheridan's striking power. From left to right are Sheridan, Forsyth, Merritt, Devin, and Custer. This photograph was taken in 1864. (Courtesy Little Bighorn Battlefield Museum.)

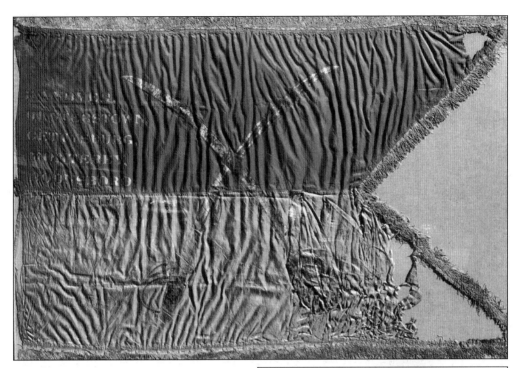

This Civil War silk flag (above) was in use for the Michigan Cavalry Brigade, the Second Brigade of the Third Cavalry Division of the Army of the Potomac. It has crossed sabers and a list of engagements. The flag can be viewed at the Monroe Historical Museum.

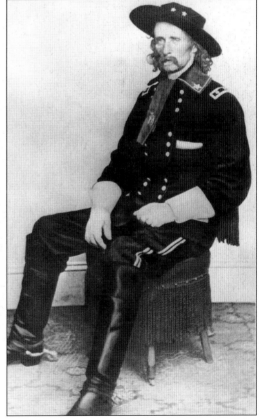

This is a photo of Captain George Armstrong Custer taken by the famous Civil War photographer Matthew Brady on May 23, 1865.

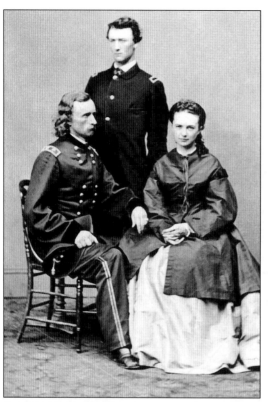

Major General George Armstrong Custer, Lieutenant Thomas Ward Custer (his brother), and Elizabeth Bacon Custer pose for a picture (left) on January 3, 1865.

The surrender at Appomattox Courthouse, Virginia, took place on April 9, 1865. General Robert E. Lee and General Ulysses S. Grant drafted and signed the surrender terms (below). Many officers were in the room to witness the historic event, including General George A. Custer. In this drawing, Custer can be seen on the far left, in the back of the room, near the cabinet. The table on which the surrender was signed was purchased by General Sheridan for a $20 gold piece and presented to General Custer as a gift for his wife. It is now in the Smithsonian, but served as a great novelty for local folks for many years.

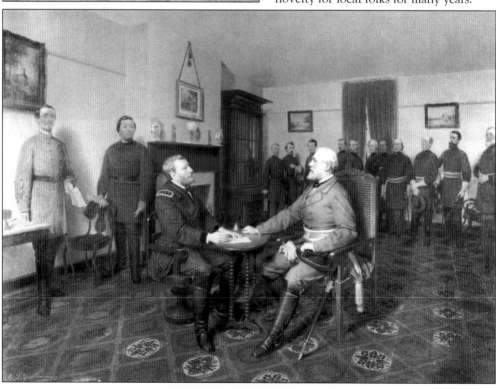

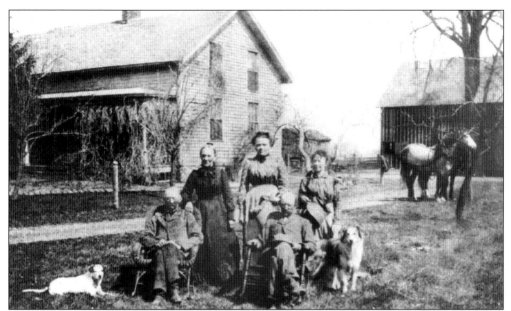

On August 22, 1871, George and his brother, Nevin, and their wives jointly purchased this house and 116 acres for $5,280. Nevin, whose rheumatic condition had saved him from the soldierly fate of his brothers, was the only one of the Custer line to have children. General Custer's favorite horse, Dandy, was buried in an orchard near the barn. Visitors to the farm included Buffalo Bill Cody and Annie Oakley. Many people of rank and position visited this house to pay their respects to the general's aging parents after he was killed. Pictured in this photograph from 1868 are, from left to right: Nevin Custer, Mrs. Nevin Custer, Annie Fisher, Armstrong Custer, and Clarabel Custer. The location is 3048 North Custer Road.

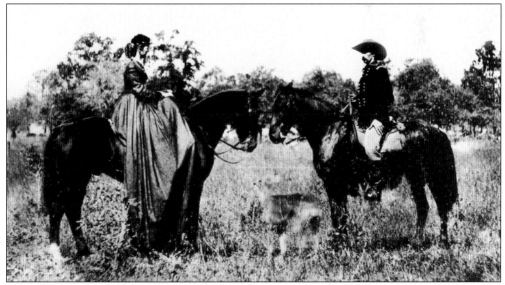

Mr. and Mrs. Custer are seen here on horseback on the Western plains. Libbie was the model army wife, following her husband to his duty stations whenever possible. She endured the hardships of frontier life so that they could be together. The Custers loved to ride horses together at whatever location his army life took them.

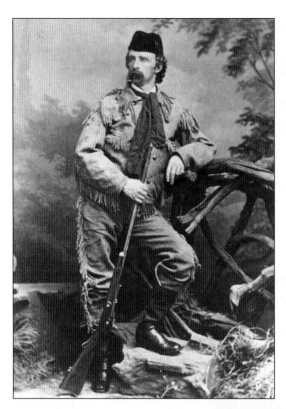

After moving west, Custer began to assume the guise of a frontiersman, setting aside his cavalier image for a new persona. This picture was taken in 1872. (Courtesy Glen Swanson Collection.)

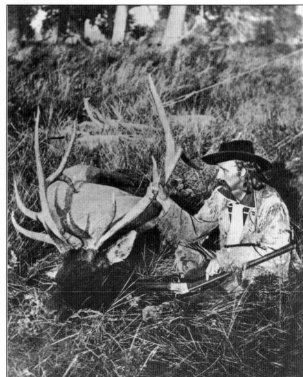

According to oral histories, this elk was shot and mounted by General Custer. This picture of General Custer with the "King of the Forest," killed during the Yellowstone expedition, was taken on September 6, 1873.

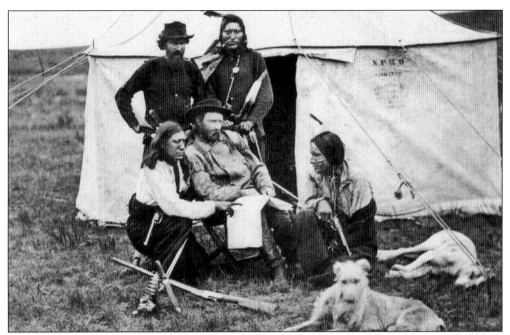

General Custer is pictured with his Indian Scouts on an expedition to the Black Hills in August of 1874. Custer is seated in the chair and Bloody Knife, his chief scout, is pointing at a map. The rest of the Indians are unidentified.

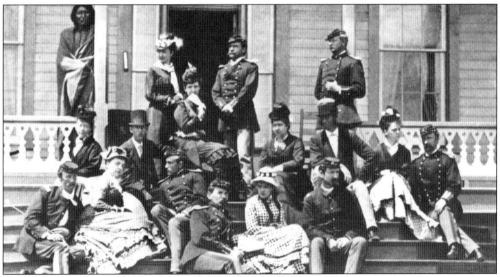

This photograph was taken in front of Custer's quarters at Fort Abraham Lincoln, North Dakota, in July of 1875. Pictured here are, from left to right: (standing) Bloody Knife, Mrs. Elizabeth B. Custer, Mrs. Margaret Custer Calhoun, First Lieutenant Algemon E. Smith, and First Lieutenant James Calhoun; (lower rows) First Lieutenant Thomas W. Custer, Mrs. Nettie Smith, Miss Emma Wadsworth, Herbert Swett, Second Lieutenant Richard E. Thompson, Captain Myles Keogh, Miss Nellie Wadsworth, Mrs. Myles Moylan, Boston Custer, Captain Stephen Bake of the Sixth U.S. Infantry, Miss Emily Watson, and Lieutenant Colonel George A. Custer. The Seventh Cavalry under Custer was the first regiment to occupy this post.

Though only 25 years old, Boston Custer had five years of experience as a forager before he was killed at the Battle of Little Bighorn in 1876. He accompanied his brother, George, on the Black Hills expedition of 1874. He was at the rear of the pack train when the Little Bighorn Valley was approached. He hurried to join his brothers when word spread that there could be a fight. His body was found, along with that of his brothers and nephew, among the 40 bodies on Custer Hill. Boston was initially buried on the battlefield, and later interred in the family plot at Woodland Cemetery in Monroe.

This is Captain Tom W. Custer at the age of 31 in 1876. When his brother George became a brigadier general commanding the Third Cavalry division during the Civil War, George arranged for his brother to be transferred to his regiment. Tom won numerous citations for bravery during the Civil War, including two Medals of Honor. After the war, when George was put in charge of the Seventh Cavalry, Tom joined him. At the Battle of the Little Bighorn, Tom's company was caught by Indians in a deep ravine. Tom Custer's body was found scalped. It was identified by a tattoo of a flag, the goddess of liberty, and the initials T.W.C.

After the Civil War, George Custer began to carry out the United States War Department policies concerning the various Native American tribes in the West. As settlers began to migrate west in greater numbers, they were put in direct competition for the land and food which sustained the nomadic Native American tribes. Thus began his long service on the western plains, extending from Texas to the Black Hills and the northern boundary, where he won fame as an Indian fighter and finally met his tragic death.

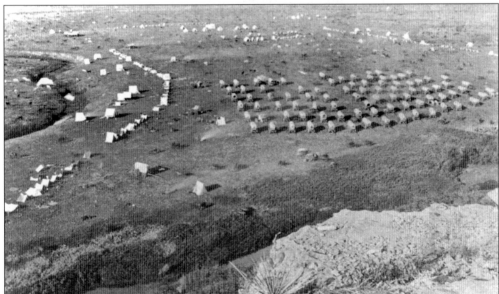

Custer's expedition into the Black Hills in 1874 included over 100 canvas-topped wagons, the entire Seventh Cavalry minus two companies on detached duty, two companies of infantry, three Gatling guns, and a Rodman cannon. The Lakota and Cheyenne viewed this as an armed invasion of their sacred hunting grounds. With over 1,000 men, 1,900 horses and mules, and 300 beef cattle, this camp at Hiddenwood Creek covered a sizable area. The purpose of the expedition party was to reconnoiter the Black Hills region.

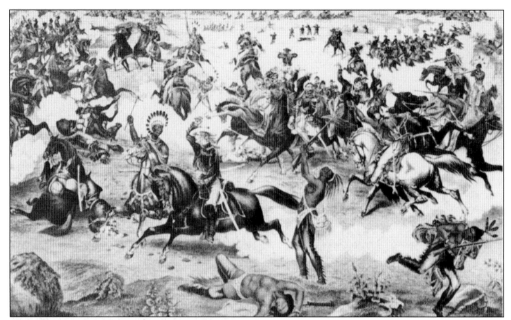

Over 100 artists have attempted to portray what no white man lived to describe. This lithograph by Feodor Fuchs, from 1876, is the earliest-known attempted depiction of the battle. The depiction makes the mistake of exhibiting Custer with a saber, a weapon that each man was ordered to leave behind. Custer and his soldiers had not realized just what they were up against. What Custer had thought to be 300 to 1,500 warriors was, in reality, between 10,000 and 12,000 Indians, of which 3,000 to 5,000 were warriors.

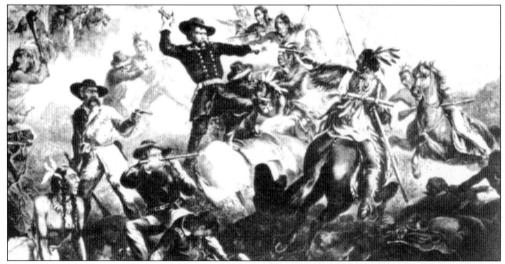

Custer and all 262 cavalry soldiers and scouts involved in the Battle of the Little Bighorn were killed by warriors of the Lakota Sioux, Cheyenne, and Arapaho tribes. There were no human survivors, but one horse, Comanche, Captain Myles Keough's horse, was found wounded and did survive. Though all of the dead were stripped, and many were mutilated, Custer was one of those unmarked except for a bullet hole in his temple and another in his left breast. All of the bodies were buried on the field in shallow graves. This depiction of the struggle was created by H. Steinegger in 1878. (Courtesy Library of Congress.)

Sitting Bull was the Hunkpapa chief and spiritual leader of the Lakota people. He was not a warrior and did not fight in the Battle of the Little Bighorn. This 1878 photograph was taken in Canada, where Sitting Bull had fled with many followers a few months after the Battle of the Little Bighorn. Sitting Bull had great influence and he was fiercely resistant to reservation life. He gained great notoriety for his role in defeating Custer, although he did not actively participate in the battle. Buffalo Bill Cody capitalized on his popularity when Sitting Bull toured with his Wild West Show. He ended up on a reservation in North Dakota. (Courtesy Glen Swanson Collection.)

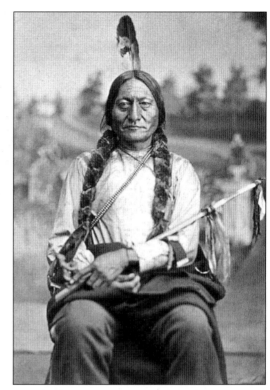

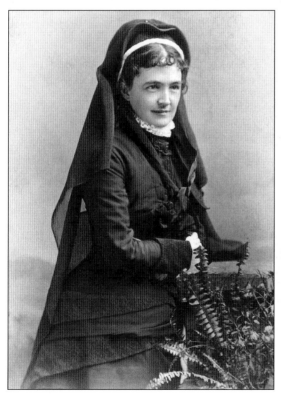

On Sunday, June 25, 1876, Libbie and other wives had gathered as usual at Fort Abraham Lincoln to sing hymns. It was not until July 6 that she was informed of the tragedy. Elizabeth Custer deeply mourned the loss of her husband. This image shows her as a young widow. She remained in Monroe for just a short time after General Custer's death, then moved to New York because she felt it was one of the few places in that day where a woman could make a living. She devoted the remaining years of her life to the preservation of her husband's memory.

Elizabeth Bacon Custer was only 34 years old when her husband was killed. This image shows her in 1910. She assisted Frederick Whittaker in writing the first biography about the life of George Armstrong Custer. She helped raise money that would eventually pay for monuments honoring Custer in Michigan and West Point. She was the author of three memoirs that related her adventures on the frontier with her husband. On April 4, 1933, just a few days before her 92nd birthday, she passed away at her apartment in New York. She was buried beside her husband at the military cemetery at West Point..

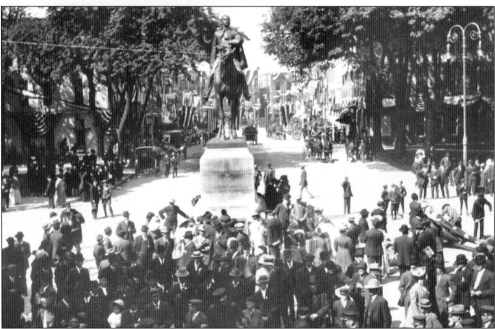

A monument was dedicated to George A. Custer in 1910. Libbie pulled the yellow ribbon that undraped the statue. Hundreds gathered for the dedication. The statue did not follow the traditional norms of the times. It had always been customary in the design of monuments that if a rider of a horse had been wounded in battle, one front leg of the animal would be raised. If the rider was killed in battle, both front legs would be lifted into the air. This statue is entitled "Sighting the Enemy," and shows Custer as he was at Gettysburg.

In 1910, veterans in Monroe paraded for the dedication of the Custer statue. Mrs. Elizabeth Custer came for the dedication, as did President Taft, who started the festivities on June 4 by paying an official visit to St. Mary's College. The dedication parade marched from Elm and Borgess to Loranger Square, where temporary grandstands had been erected, facing north and stretching across Washington Street from the courthouse to the First Presbyterian Church. Also at the unveiling, as seen below, there was a parade of Civil War veterans on horseback who galloped through the streets.

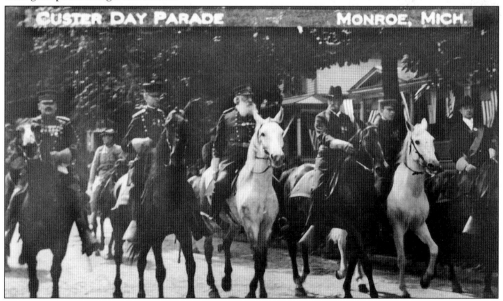

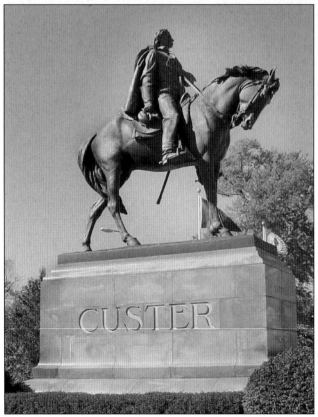

This statue, designed by sculptor Edward C. Potter with suggestions from Libbie Custer, was entitled "Sighting the Enemy," and was erected by the State of Michigan at a cost of $25,000. The unveiling (shown above) took place on June 4, 1910, and was attended by Elizabeth Custer and President William Howard Taft. Hundreds from the Monroe area attended the dedication. Custer is depicted in the Civil War uniform of a major general and the statue shows him as he was at Gettysburg when, at the age of 23, he led his famed Michigan Brigade and defeated Confederate J.E.B. Stuart despite being badly outnumbered. Potter was selected as the artist because of his reputation for sculpting equestrian statues. This memorial is regarded as one of the finest of its kind in the world.

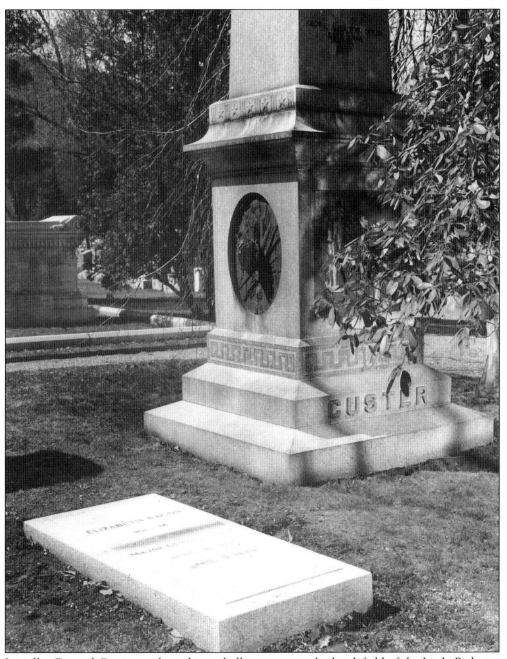

Initially, General Custer was buried in a shallow grave on the battlefield of the Little Bighorn. On October 10, 1877, his body was interred at West Point. Emanuel Custer (George's father) and his daughter, Nettie, traveled east for the service, and Libbie traveled from New York. Custer's coffin was covered with the Stars and Stripes as well as his sword and plumed dress helmet. The coffin was taken to the grave by a caisson, which was followed by a lone horse with spurred boots pointing to the rear. On April 6, 1933, just two days before her 92nd birthday, Libbie was buried next to her husband.

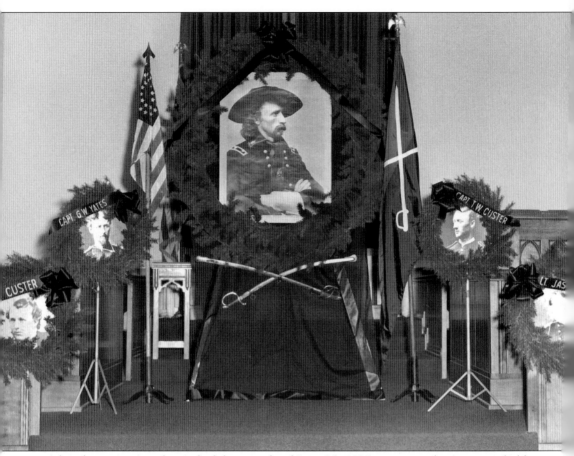

After the community learned of the tragedy of June 25, 1876, a memorial service was held at St. Paul's United Methodist Church on August 13, 1876. On that day, the church was filled to capacity and pictures of the men from Monroe were displayed during a 30-day mourning period. On the 100th anniversary of Custer's death in 1976, a similar memorial service was held. The church was decorated for the occasion, a color guard presented the colors, and taps was played at the conclusion of the service.

Six
PLACES OF WORSHIP

Churches have been an important part of Monroe's history since the establishment of the area as a permanent settlement. St. Antoine's Catholic Church was organized in 1788 by missionary Father Frichett for the pioneering French families that were settling on the River Raisin. The first church structure was built in 1788 on a farm two miles west of present-day Monroe on the north side of the river. The first Catholic burial ground was located on the same land. The church was consecrated in 1789, and the first resident priest was Reverend Edmund Burke. The church was located in St. Antoine's parish, which, at the time, constituted all of what would become Monroe County. Father Gabriel Richard, the famous missionary, printer, and priest, was minister of the parish from 1805 until 1827. Construction on the present-day structure began in 1834, and the name was changed to St. Mary's Catholic Church. It is the second-oldest Catholic Church in Michigan. Father Louis Florent Gillet arrived in Monroe in 1845 and became resident pastor. The present church building was consecrated in 1839. It was during Father Gillet's term of service that the Sisters, Servants of the Immaculate Heart of Mary (IHM), was established as a unique religious order. Father Edward Joos became director and superior of the Sisters, Servants of the IHM, in 1857 and served for more than 40 years. He was chaplain of St. Mary's Academy until the time of his death in 1901. Father Joos was largely responsible for the growth of St. Mary's Academy into an institution of importance and influence. He was a very influential man in the community and was twice made vicar general of the Diocese.

St. Michael's Parish was organized by Father Kronenberg, who belonged to the order of Redemptorists. In 1845, the first church structure was built. Several years later, it was abandoned, and St. Michael's German Catholic Church was organized in 1855 and a frame church building erected. This structure served for a long time as a parochial school. The present church was erected in 1867 and Father Schmittdiel was pastor from 1863 until his death in 1899. St. John's Catholic Parish was founded by Reverend C.P. Macs in 1872. The church was organized by the English-speaking peoples of St. Mary's and St. Michael's congregations and the present church was erected in 1874 by William Gilmore, a pioneer resident of Monroe.

Among the Protestant churches established in Monroe, First Presbyterian is one of the oldest. It is the oldest Presbyterian church in the state. It was organized by Reverend J. Monteith in 1820 and services were first held in the old Yellow Courthouse, which stood on the southwest corner of the Public Square. The first church structure was built on the southwest corner of Cass and First Streets, and then in 1846, the present church building was erected. The membership of this church included many men and women prominent in the history of Monroe from its early pioneer days. General George A. Custer and Elizabeth Bacon were married in this historic church on February 9, 1864.

Methodism was established in the Monroe area in 1808. Services were first held by an itinerant minister, Reverend William Mitchell. Services were also held in the home of Daniel Mulhollen as early as 1817. In the beginning, the congregation consisted of three families. The Methodist church was reorganized in 1821 by Reverend J. Kent and the first meeting house was a frame building on the present site of St. Paul's United Methodist Church. In 1871, the now imposing structure was dedicated.

The Monroe County Bible Society was organized in 1820 by 17 of the first settlers. This Bible Society was the forerunner of the Monroe County Sunday School Association which was organized c. 1878. The Trinity Episcopal Church was organized in 1832. The original church building burned in 1868, and the following year, the present church was built. The first Baptist church was organized in the old Yellow Courthouse in 1834, but the congregation did not have a permanent pastor until 1843. They had no house of worship of their own until the old Presbyterian Church was leased to them in 1846. Then, in 1871, a church building was constructed on Washington Street. Today, that structure serves as home to the Monroe Outreach Assembly of God congregation.

The first German Lutherans came to Monroe in 1828, and six years later, a congregation was established and the first services were held in the Episcopal Church building. In 1839, a log cabin church, called the Zoar Church, was built about four miles south of Monroe. Five years later, Reverend William Hattstaedt was called to be pastor and he established one congregation in the city and one at Sandy Creek, comprising one parish. In 1847, a number of the German families withdrew and formed the Zion Church. They purchased the old Presbyterian church building where services were held for several years. Then in 1883, they erected the church which they now occupy. In 1849, the Trinity Lutheran Church purchased the property at Scott and Third Streets and erected a frame church. In 1893, this building was replaced by the present church building. That same year, representatives of Lutheran Churches in Detroit and surrounding cities proposed the establishment of a Society of the Evangelical Lutheran Old Folks Home of the State of Michigan. The first facility built by this organization consisted of 20 rooms and was located on 12 acres of land on South Monroe Street. It was dedicated in 1894 and was named the "Altenheim." The idea was to provide Christian care to seniors of all faiths. This service is still provided today.

The beautiful church structures of Monroe, many of which are still standing, are a testament to the faith that has always been extremely important and essential to many residents, and which will always be interwoven into the legacy of the area.

This church, St. Mary's Catholic Church, is the immediate successor to the first church of Monroe County, St. Antoine aux Riviere Raisin, which was founded on October 15, 1788, two miles upriver. Construction of the present church started in 1834 and it was consecrated in 1839. The name was changed in 1845. During the pastorate of Father Florent Gillet, the order of the Sisters, Servants of the Immaculate Heart of Mary, was founded here in 1845. The parish continues to flourish and prosper to the present day. It is located on the corner of North Monroe Street and West Elm Avenue.

St. Antoine's Catholic Church was founded by missionary Father Frichett. It was located in St. Antoine's parish which, at the time, constituted all of Monroe County. Today known as St. Mary's Catholic Church, it is the second-oldest Catholic church in the state. The structure is a combination of Greek Revival and Gothic Revival architecture.

87

On November 28, 1889, the 100th anniversary of the dedication of the first church (St. Antoine's) was memorialized by the unveiling of the granite monument which stands in front of the St. Mary edifice. The statue was cut from Italian Carrara marble and stands six feet high. Just below the statue is the seal of the County of Monroe with the centennial dates. Below that is a quotation from a letter by President George Washington to the Catholics of America. On a sandstone plinth are inscribed the names of the honored guests at the centennial celebration, including Bishop Foley of Detroit, Honorable Cyrus Luce, governor of Michigan, and the mayor of Monroe at the time, Charles Golden.

Father Bernard Godfreid Soffers served at St. Mary's Parish from 1873 until his death in 1899. He was born in Holland in 1826 and was ordained to the priesthood on May 25, 1850. He came to America in 1853 and was sent to Ste. Anne's Church in Detroit. During his pastorate at Ste. Anne's, he held services in the Belgian and Dutch languages and had charge of the first black Catholic congregation in Detroit. He was assigned to St. Mary's Parish in Monroe in 1873. At the same time, Soffers served the missions at New Boston and Rockwood, with congregations numbering about 500 families.

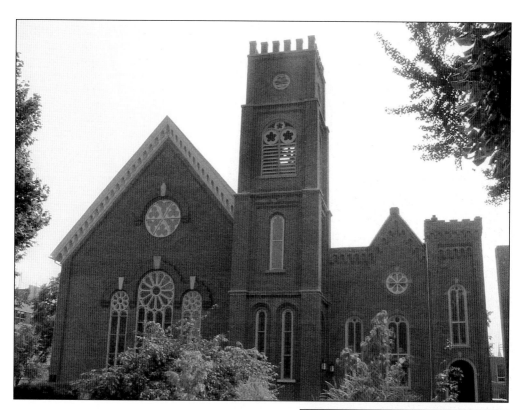

First Presbyterian is one of Michigan's oldest Presbyterian churches. It was organized by Reverend J. Monteith in 1820 in the old Yellow Courthouse, which stood on the southwest corner of the Public Square. The first church was built on the southwest corner of Cass and First Streets and then, in 1846, the present church building (above) was erected, making this building the second-oldest house of worship in the city of Monroe. The membership of this church included many prominent men and women from the early history of Monroe. It was in this church that George Custer and Elizabeth Bacon were married on February 9, 1864.

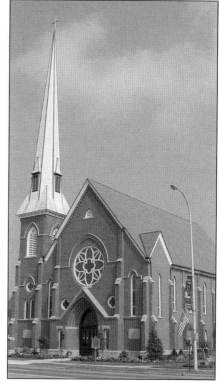

Methodism was established in the Monroe area in 1808, with services held by an itinerant minister, Reverend William Mitchell, as early as 1811. Services were also held in the home of Daniel Mulhollen as early as 1817. The congregation then consisted of three families. The Methodist church was reorganized in 1821 by Reverend J. Kent, and the first meeting house was a frame structure built in 1836. In 1869, construction began on the imposing structure that stands today at Second Street and South Monroe Street (right).

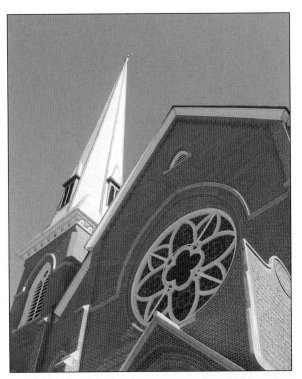

In 1871, the present church was dedicated as the First Methodist Episcopal Church. The new church was dedicated with a comfortable seating capacity of 600, the structure was heated by steam, and there was an excellent organ within. It remains one of the finest edifices in the area. It became St. Paul's Methodist Episcopal in 1901 and St. Paul's United Methodist in 1969. Extensive renovation of this beautiful church began in 1974, uncovering long-lost treasures of furniture, woodwork, and stained glass.

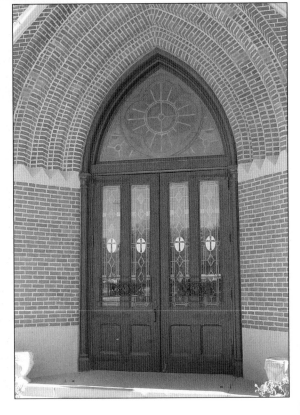

The Custer family were members of the First Methodist Episcopal Church (St. Paul's United Methodist Church). Lieutenant James Calhoun married General Custer's sister, Margaret, in this church on March 7, 1872. Four years later, special services were held here for the six Monroe men who died at the Battle of Little Bighorn. One hundred years later, in 1976, a bicentennial memorial service was held in memory of these same men.

St. Michael's Parish was organized by Father Kronenberg who belonged to the order of Redemptorists. In 1845, the congregation's first church was built. Several years later, the mission was abandoned and St. Michael's German Catholic church was organized in 1855. A frame church was erected and served for a long time as a parochial school. The present structure was completed in 1867. The steeple was not part of the original construction, but was added in 1883. Below is St. Michael's parish house. It is located at 502 West Front Street.

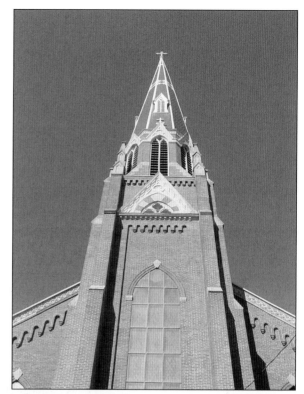

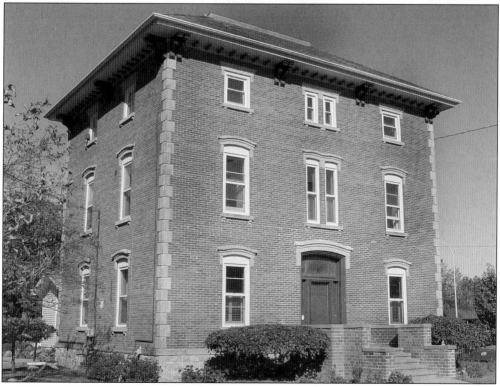

Father Benjamin D. Schmittdiel was born in Lancaster, Pennsylvania, in 1834. His parents moved to Detroit when he was three years old. At the age of 20, he entered the seminary of St. Thomas, near Beardstown, Kentucky. After finishing his studies at St. Thomas, he was sent to Milwaukee for the study of theology. He was ordained a priest in 1863 and appointed to St. Michael's in Monroe. Father Schmittdiel served as pastor of St. Michael's from 1863 until his death in 1899. He was lovingly regarded by the large congregation he served and by citizens in general. It was during his pastorate that the present structure for the church was constructed on Front Street.

The first German Lutherans came to Monroe in 1828. Six years later a congregation was established and the first services were held in the Episcopal Church building. In 1839, a log cabin church called the Zoar church was built about four miles south of the city. One of Michigan's oldest churches, Trinity Lutheran was organized in 1844, and joined the Missouri Synod in 1848. In 1849, the Trinity Lutheran Church purchased property at Scott and Third Streets and erected a frame church which served as both a church and school until the Christian Day School was constructed in 1869. It is located at 323 Scott Street.

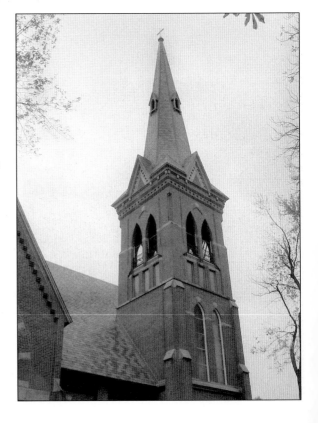

In 1893, the frame structure which had served as the Trinity Lutheran congregation's place of worship was replaced by the present church building. Placed in the cornerstone for the new church was a Bible, a copy of the Book of Concord, the church constitution, a list of voting members and officers, Monroe newspapers, and a photograph of the old church. The open belfry contains the original bell. The structure is an exceptional example of Gothic Revival with pointed arches on the windows and doorways.

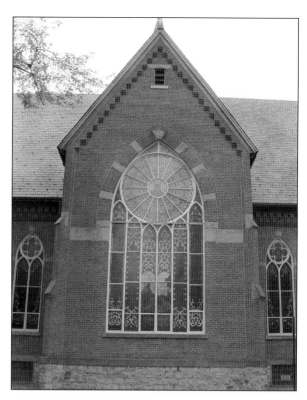

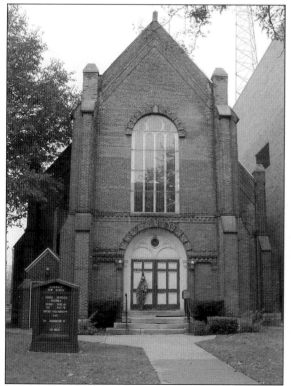

The first Baptist church in Monroe was organized in the old Yellow Courthouse in 1834, but its first pastor was not called until 1843. The congregation had no house of worship until the old Presbyterian Church was leased to them in 1846. A church building was constructed on Washington Street in 1871. Today, that building serves as a house of worship for the Monroe Outreach Assembly of God, located at 214 Washington Street.

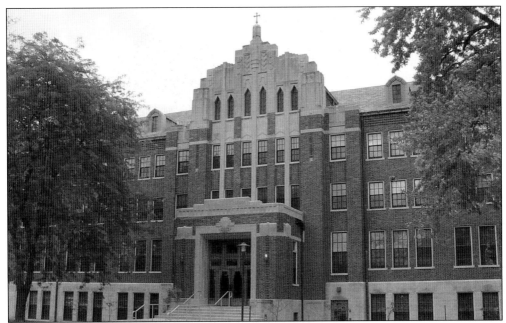

The Congregation of the Sisters, Servants of the Immaculate Heart of Mary, was founded in 1845 by a Belgian missionary, Father Louis Florent Gillet. The first four members of the order began their education work in a log cabin convent on the banks of the River Raisin. They were Theresa Maxis, Ann Schaff of Baltimore, Theresa Renauld of Grosse Pointe, and Madame Godfrey Smith of Monroe. Theresa Maxis, known in the community as Mother Theresa, was the first superior. The present structure is located at 610 West Elm Avenue.

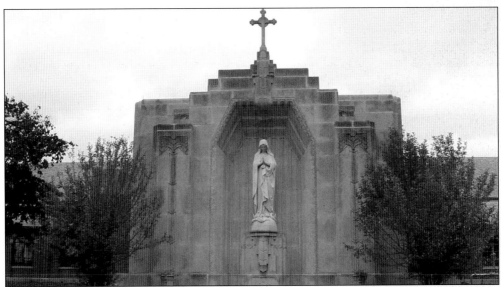

The Congregation of Sisters, Servants of the Immaculate Heart of Mary (IHM) were sent on missions throughout the country, and in 1948, the first IHM mission outside the U.S. opened in Cayey, Puerto Rico. Today, IHMs are still active throughout the world with members serving as teachers, administrators, pastoral workers, and social services workers. There are 250 IHM sisters now in residence at the Motherhouse in Monroe.

Father Edward Joos was director and superior of the Congregation of Sisters, Servants of the Immaculate Heart of Mary for more than 40 years. He was chaplain of St. Mary's Academy until the time of his death in 1901. In 1860, he was responsible for establishing a home for orphan girls that came to be known as St. Mary's Home. Father Joos was largely responsible for the growth of St. Mary's Academy into an institution of importance and influence. He was a very influential man in the community and was twice made the vicar general of the Diocese.

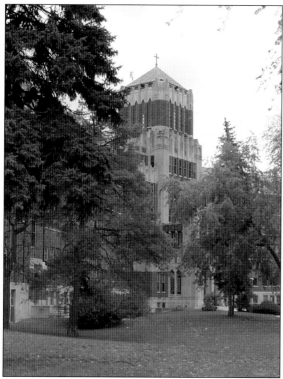

In 1845, Monroe was a flourishing county seat and had no school for the daughters of the descendants of French Canadians who were Catholic. St. Mary's Academy was opened in 1846 with 40 students. St. Mary's College was incorporated under the laws of Michigan in 1910. By 1920, the growth of both the academy and college necessitated the construction of a new facility. On June 3, 1929, St. Mary's Academy was destroyed by fire. The sisters took on the Herculean task of reconstruction of the motherhouse and academy at the onset of the Great Depression. Amazingly, the school community was able to move into new buildings by 1932. Marygrove College was built in Detroit and continues to serve the needs of women and men today. In the fall of 2000, the IHM community began a major renovation of the 70-year-old motherhouse and health care center.

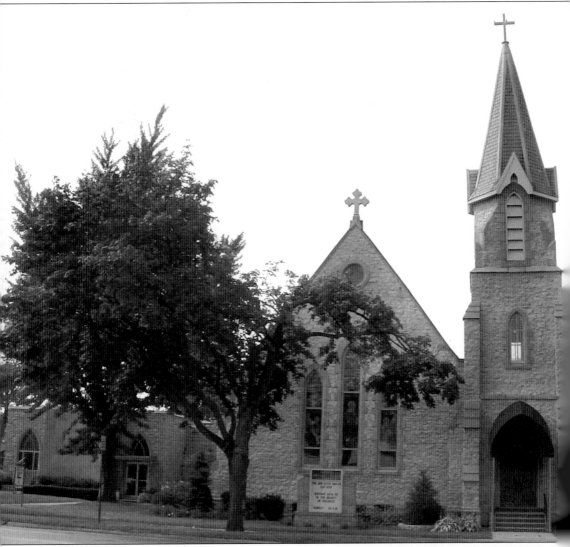

The Trinity Episcopal Church was organized in 1832. The original church structure burned in 1868 and the present church was built the following year. Annie Yates sang in the choir here. She was the wife of Captain G.W. Yates, who died at the Little Bighorn. A close friend of Mrs. Custer, Annie and her three children moved back to Monroe after the battle. Their home was located one block south and across the street from the church. Mrs. Yates later moved to New York where, in 1914, she was killed when her dress got caught while mounting a subway car. The church is located at 304 South Monroe Street.

Seven

ARCHITECTURE TELLS A STORY

The story of an area and insight into the history of a region is revealed in a unique way by architecture. This is certainly true of the Monroe area. The structures that settlers lived in and operated in tell the story of what life was like during different periods of history. To look at an area's history from this perspective, one can clearly see that the story begins with a river. The River Raisin was the reason Native Americans built their temporary dwellings in the area. The same can be said of the early French settlers and pioneers from the East. As various peoples came to the Monroe area, they built structures that met their needs.

Unfortunately, none of the bark- and reed-covered houses of the Native Americans have survived, but there are drawings of what the Native Americans built (see page 13). Since the villages were only used as temporary campsites while groups came and went, the structures were fairly simple and crude, but they served the purpose. Cut young trees were placed in the ground in an oval shape; their tops were then bent over to form a roof. The frames were covered with dirt, grass, and bark. A hole was left in the top to permit smoke from the fire inside to escape, and an opening on the side covered with animal skin served as a door.

The first European settlers to the Monroe area were of French descent. Starting in the 1780s, they came from Detroit and built their homes of logs or hewn timbers, following the traditions of construction in French Canada (see page 18). Many of these early structures were rectangular with the long axis parallel to the river. There was a loft with a window for light. The French settlers of this era used three traditional techniques in the construction of their dwellings: vertical posts set in trenches in the ground, or with the lower ends mortised into a sill, horizontal log construction, or braced frame design.

As settlers of other ancestry made their way to the River Raisin, a new type of log dwelling began to appear. Many of the settlers that started to come from the East erected more temporary cabins in anticipation of building more permanent structures. The logs were hewn to a thickness of between five to seven inches and the corners were notched to fit together. The space between the logs was filled in with clay or mortar. The doors and windows were cut out after the walls were erected. A good example of this kind of construction and architecture is the log house built by Johannes Eby in 1857, which still stands today in Monroe (see page 42).

Thomas Jefferson was a proponent of architecture that reflected the classical designs of Greece and Rome, and he encouraged people across the nation to adopt such styles. In the early 1800s, this type of architecture was given the name Greek Revival. This style imitated elements

of ancient Greek temple design. It reached Monroe in the 1830s, and many great examples still exist today. The stone columns, friezes, cornices, and pediments of ancient Greece were recreated in wood. What kind of statement did this kind of architecture make about society? The answer is important when related to establishing a life in the wilderness: "The temple forms of the Greek Revival period expressed the nobility of man; they signaled the coming of civilization to the frontier."

The next era of structures built in Monroe followed more of a functional approach, in which builders mixed styles quite frequently. Styles that were nationally prominent usually paid a visit to Monroe. In the later half of the 19th century, the popular styles included Gothic Revival, Second Empire, and Italiante or any combination thereof. Gothic Revival was inspired by the prominent features of Gothic cathedrals. Second Empire included styles from the French Renaissance period. And Italianate was derived from the villas of Italy. Interestingly, few buildings constructed at this time were actually designed by an architect, but instead, the designs were found in builders' manuals.

During the last part of the 19th century, the buildings of Monroe were designed with a freedom unlike anything that had been seen before. As the area grew, and the demand for housing increased, builders started to create structures more uniquely American. Many descriptive terms have been offered for the buildings of this era, including Victorian, Free Classic, Free Jacobean, Modified English, Modern American, Queen Anne, Eastlake, Stick, and Shingle style. One hundred years after the American Revolution, another revolution was going on in Monroe: an architectural one.

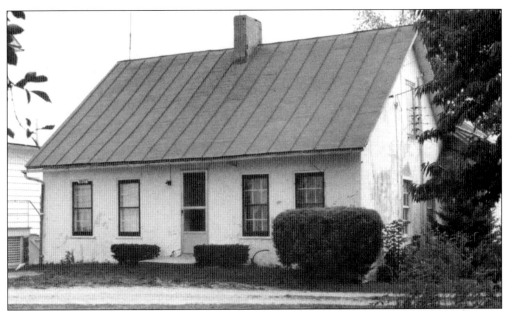

Although little is known of this structure's early history, it was located on the banks of the River Raisin on the land of Roue Cloutier. The home's many features suggest the influence of early French architectural tradition. The structures were rectangular with steeply-pitched roofs. As seen here, the building was usually symmetrically arranged and heated by a fireplace or iron stove. The houses were also whitewashed inside and outside.

Stone structures are relatively rare in Monroe County. This building was erected about 1827, using stone transported from Kelly's Island. The Oliver family was the earliest occupant. The Classic detail, as seen in the detailed cornice of this structure, was introduced to the frontier prior to the advent of Greek Revival style. It is located at Second and Harrison Streets.

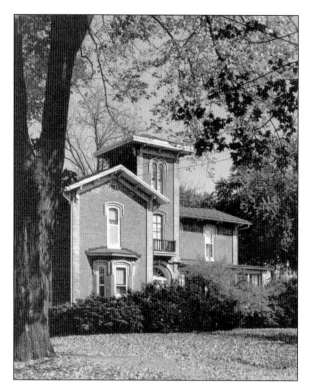

Once called the Blind Baby's House, it is believed that the structure was built by Julius Weiss, a German apothecary, in the early 1800s. Concerned about the welfare of blind children, a local group of citizens converted the building for their use. This house is one of the finest examples of the Tuscan Villa motif of the Italianate Style to be found in Michigan. It is located at Vine and Tremont Streets.

This stately example of Greek Revival architecture, built in 1837, was home to Frederick Nims, aide to General Custer during the Civil War. It was built by Rudolph Nims, Jacques Godfroy, and John Birch, partners in a land speculation company. The structure was renamed "Shadowlawn" after extensive remodeling in 1914. The house, located at 206 West Noble Avenue, is on the National Register of Historic Places.

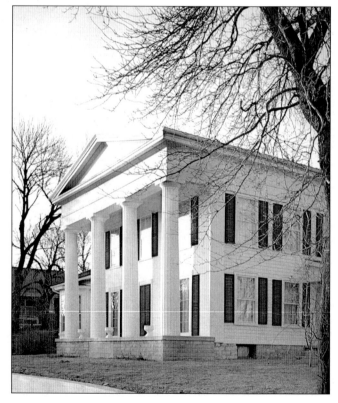

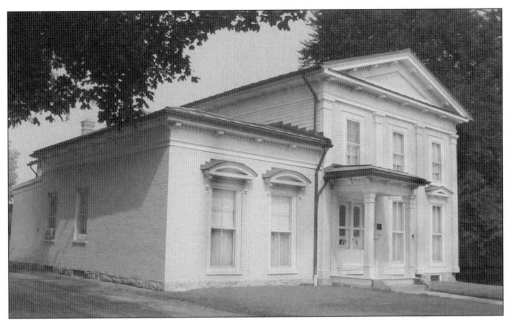

Robert McClelland—state legislator, member of Congress, governor of Michigan, mayor of Monroe, and President Pierce's secretary of the interior—was the most prominent resident of this house. Built in 1835–1836 by Ebenezer Howes, this structure demonstrates many classic Greek Revival architectural elements. There are large pilasters supporting a full pediment. There is rope detail on the columns supporting the front entry portico and along the cornice. It is listed on the National Register of Historic Places and is located at 47 East Elm Avenue.

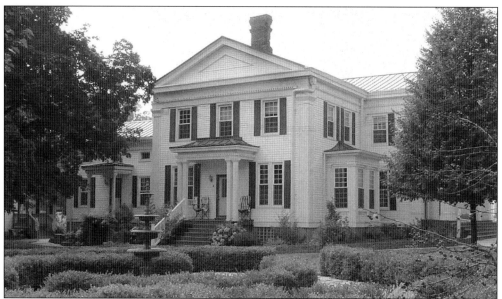

The architecture of the Ilgenfritz House is known as the Temple form of Greek Revival. Large square columns support a full pedimented portico roof. I.E. Ilgenfritz came to Michigan from New York in 1847 and brought with him a small stock of fruit trees. He helped to establish one of Michigan's first large-scale commercial nurseries. The home is located at 62 East Elm Avenue.

The Ilgenfritz House was built by Major Henry Smith in 1835 and is one of the better-known historic homes in Monroe. Located at 62 East Elm Avenue, it is on the National Register of Historic Places.

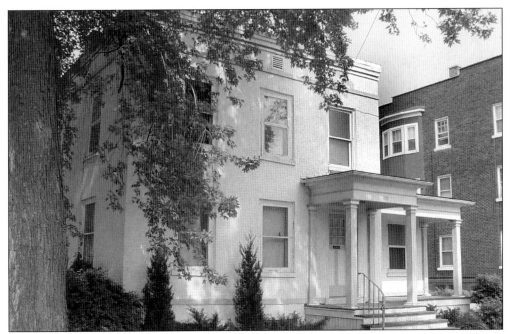

This structure was built in 1840. It represents the cube form of the Greek Revival style, with corbelled brick cornices. The Greek Revival architecture is highlighted by a classically-inspired portico and is one of Monroe's most prominent examples of a "temple in the wilderness." Because of Thomas Jefferson's promotion of an architecture based on the classical styles of Greece and Rome, a new style was born and became known as Greek Revival. This new style reached the frontier in the 1830s and "Greek Temples" began to appear next to the early log cabins and clapboard houses. This structure is located at 103 East Elm Avenue.

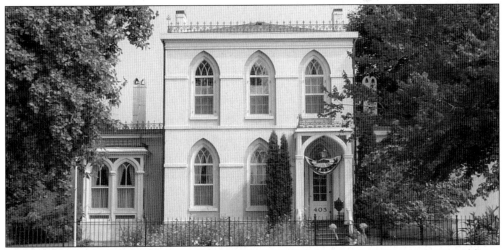

William H. Boyd was a Monroe merchant and a participant in the founding of the Republican Party. With his brother, Erasmus, he helped found the Young Ladies Seminary, which Libbie Bacon attended. Local legend claims that Boyd's Irish Gothic Revival house was used to hide escaped slaves, and that it is still haunted by his three-year-old daughter, Clara Anne, who died during a scarlet fever epidemic in 1860. It has pointed arch windows and cast iron detail on the roof edge, and is located at 405 Washington.

The Meier house, built in 1880, illustrates the complexity and freedom of Victorian and Queen Anne architecture. It cost $3,200 for Frederick W. Meier to build his 16-room home. He was born in Hanover, Germany, in 1852. Not long afterward, his family came to Monroe, established a farm, and his father was employed as a miller. Frederick attended the parochial school of the German Lutheran Church in Monroe and was employed as a clerk in a book and stationery store. After serving for nearly 20 years as a clerk, he purchased the business and was very successful in the venture. He was known in the community as a man of integrity and honor.

Once considered one of the finest homes in Monroe County, this house was built in 1876 by Austin B. Chapman and exhibits many Second Empire features. French Renaissance architectural elements were revived in the later half of the 19th century and the style became known as Second Empire. One of the major characteristics of Second Empire architecture was a Mansard roof. This unique roof design features two slopes on all four sides of the structure. The upper slopes were often slanted inward in order to collect rainwater. This home is located on Dixie Highway.

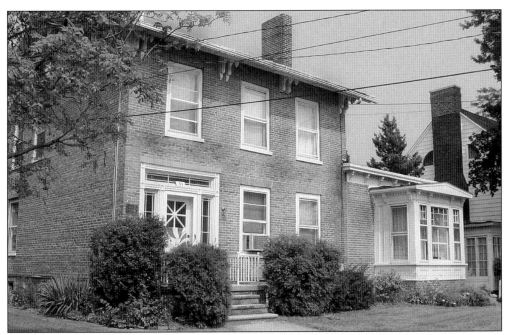

Built around 1870, this structure is considered a transitional design, early to late Victorian. Notice the ornamental brackets and the detail on the front entry. It is located at 31 Elm Avenue.

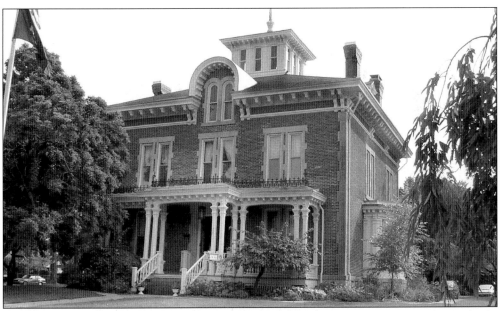

This charming Italianate home was completed in 1873. Dr. Sawyer built the house for his bride. He was a prominent citizen in Monroe and a major proponent of homeopathic medicine. The home was given to the City of Monroe by Dr. Sawyer's daughter, Jenny Toll Sawyer, in 1938. Since then, it has been used by the Red Cross, the Camp Fire Girls, the Boy Scouts, and the Monroe County Historical Museum. Today, the home is the site of the Sawyer Homestead, an organization established to preserve the historical significance of the structure in the community. It is located at 320 East Front Street.

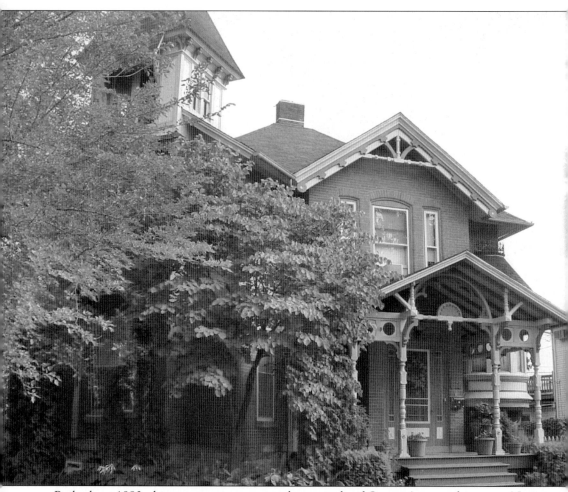

Built about 1880, this structure is a spectacular example of Queen Anne architecture. Notice the corner turret, corner towers, and ornamental woodwork. This style was introduced to the United States at the Philadelphia Centennial Exposition in 1876. The design is non-symmetrical and spread quickly across the country. The building is located at 203 Cass Street.

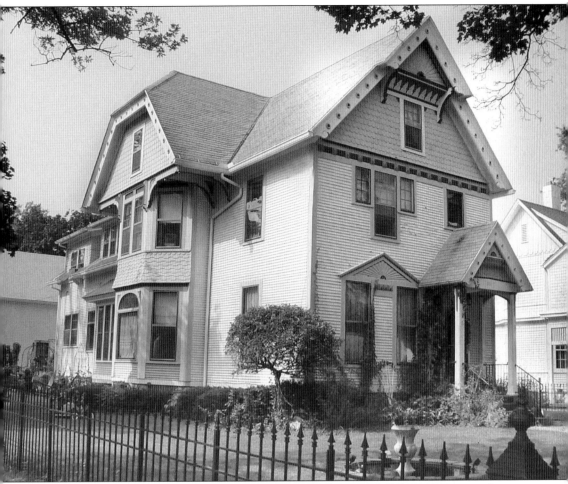

This Queen Anne structure, 325 South Macomb, was built in 1880. It has a unique sunburst pattern and fish scale shingles on the gable end. There are beveled corners on the south side projection and a round arch on the front entry. The style manifested a variety of forms, texture, material, and colors. The many varied windows often exhibited colored glass panels. It can best be characterized as a richly decorative style that provided an exuberant visual display.

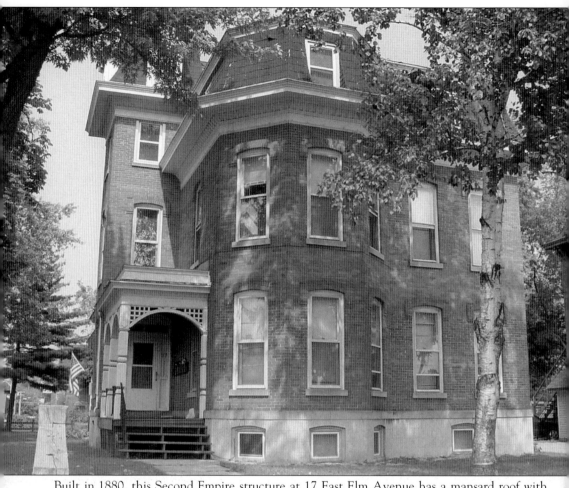

Built in 1880, this Second Empire structure at 17 East Elm Avenue has a mansard roof with window hood moldings.

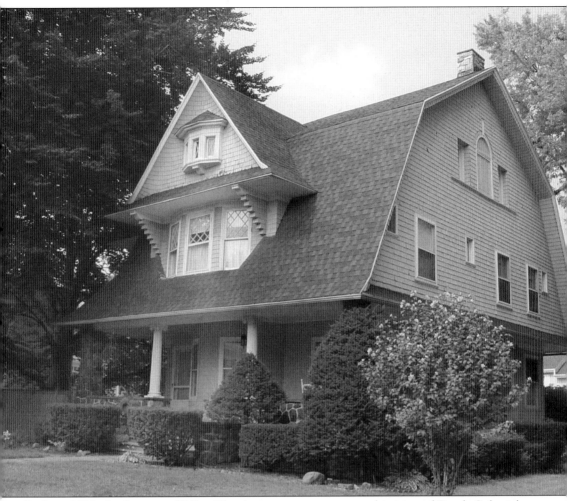

Built in 1898, this house at 57 East Elm Avenue represents a combination of Dutch Colonial and Shingle style. It has ionic columns on the porch, a gambrel roof, a projecting front gable, and a palladian window in the main gable end. This American style originated in homes built by German settlers as early as the 1600s. A hallmark of the design is the broad gambrel roof that extends over the porches, creating a barn-like effect. The style enjoyed a revival during the turn of the 20th century, as the country looked back with nostalgia to its colonial past.

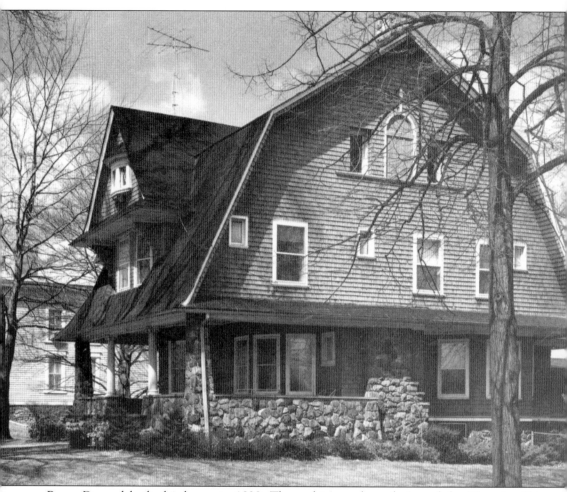

Boyez Dansard built this house in 1898. The architectural revolution of the Victorian Era closed with the introduction of the Shingle style and what has been called a Colonial Revival style of American architecture. Dansard left behind a career as a banker when he teamed up with George Little to establish a business in the field of insurance in 1858. Through the years, the business ownership was transferred to the employees, preserving the knowledge and dedication that the name Dansard-Little represents. This home is located at Elm Avenue and Tremont Street.

Eight

HISTORY LIVES IN MONROE

History is alive and well in Monroe and the larger area. There are many opportunities for the general public to learn about the rich heritage of the area in a number of different ways and venues. The place to begin is the Monroe County Historical Museum. Located in downtown Monroe, the beautiful building served as a post office in 1910. In 1972, the structure was acquired by the La-Z-Boy Chair Foundation for use as a museum. It houses one of the largest collections of 18th- and 19th-century artifacts relating to southeast Michigan. The stories of the area are powerfully told through signage, artifacts, brochures, and arranged guided tours. Among the exhibits are the following: The First Americans, The French Habitants, Early Michigan, General George Armstrong Custer, Victoriana, and Veterans.

Monroe County has a rich heritage of Native American lore. More historic and prehistoric archaeological sites are registered in Monroe County than in any other county in Michigan. The First Americans exhibit focuses on Paleolithic through the Late Contact period, including items from tribes associated historically with Monroe: the Potawatomi, Odawa, Wyandot, and Ojibwa. Featured are a dugout canoe and a reproduction birch bark canoe, as well as a beaded papoose carrier used by a local metis family. The French Habitants exhibit displays a significant collection of authentic 18th-century items from the Monroe area's earliest settlers. The exhibit tells the story of the pioneer lifestyle of the early French settlers, which fostered a tradition of freedom in the outdoors common to market hunters, decoy carvers, trappers, and fishermen. When Frenchtown was almost destroyed during the War of 1812, the habitants would have starved without the muskrat as a source of food. The muskrat tradition lives on today, in cuisine and story. The Early Michigan exhibit details the many important people and events in Michigan's move to statehood. Also in this display is the exciting tale of the potential civil war that was barely averted in Monroe County during the Toledo War of 1835, in which Michigan lost Toledo, but gained the Upper Peninsula. The General George Armstrong Custer exhibit is housed on the second floor of the museum and is one of the nation's largest public exhibits on General Custer. The displays trace General Custer's genealogy and birth, his association with Monroe, his West Point experience, his Civil War victories, and his ultimate demise at the Little Bighorn. Custer's interests in outdoor life, travel, target shooting, hunting, and taxidermy are highlighted. The effect of Custer and his legend can be seen in displays showing the efforts of Civil War veterans to memorialize him, and through the life and works of his beautiful widow, who remained steadfast to his memory until her death at age 91. The rest of the Custer

family is not forgotten in the exhibit, the military legacy is traced through post-World War II. Superb examples of Victorian furniture, glass, decorative arts, and clothing can be seen from the museum's extensive holdings. Much hardship was endured in transporting some of the early furniture pieces to the Monroe area. Monroe prospered through the entire Victorian period (1837–1901), and many treasured items have been donated to the museum. Unique pieces of furniture made in Monroe are part of the display, and portraits, landscapes, and still lifes created by local artists grace the walls of the Victorian room. Reflecting the rich military tradition of Monroe, the museum displays many war-related items used by Monroe County Veterans. Displays include artifacts from the Toledo War, Civil War, Spanish-American War, World Wars I and II, Korea, Vietnam, and Desert Storm. The Civil War is especially well represented. The centerpiece of the exhibit is the regimental flag of the Seventh Michigan Infantry, which was mustered in Monroe. Many exhibits are rotated throughout the year so that there is always something new to see and learn. The museum also houses a professionally-staffed archive which stores maps, family papers, documents, photographs, and genealogical documents relating to Monroe County.

The Navarre Anderson Trading Post Complex represents a French pioneer homestead along the River Raisin. The complex is accessible to visitors, who can view the oldest wooden structure still standing in the state. The main building, built in 1789, is the most complete example of French-Canadian "piece-sur-piece" construction in the Old Northwest. Other buildings include an 1810 cookhouse and a replica 1790s French-Canadian-style barn. Each year towards the end of October, Monroe County's colorful history comes to life in the glow of lanterns, fires, and torches, as costumed guides conduct evening group tours of the Trading Post Complex.

The River Raisin Battlefield Visitor Center interprets the history of one of the largest engagements of the War of 1812. The massacre of wounded soldiers the following day shocked and enraged Americans throughout the Old Northwest Territory. The displays at the visitor center include dioramas and full-size British and American soldiers. There is also a fiber-optic map presentation on the Battle of the River Raisin that explains the logistics of the forces involved. Signage behind the visitor center tells the story; there is also a replica gun sled on site just like the British would have used. Every year on the Saturday in January closest to the date of the battle, a commemoration ceremony is held.

A brochure can be obtained at the museum, whereby one can trace the steps of General George Armstrong Custer. There are numerous Custer-related sites still standing. There is also a brochure that lists the War of 1812 Historical Markers and their locations. On the list is Memorial Place, where unidentified remains of victims of the River Raisin massacre were buried in 1813. A beautiful monument stands on the site as a permanent tribute to the Kentucky militiamen. A walking tour is available of historic Monroe and includes homes that date back as far as the 1830s.

The above are just a few of the great opportunities available. It is rewarding to learn about and experience the rich heritage of Monroe. History is alive and well on the River Raisin!

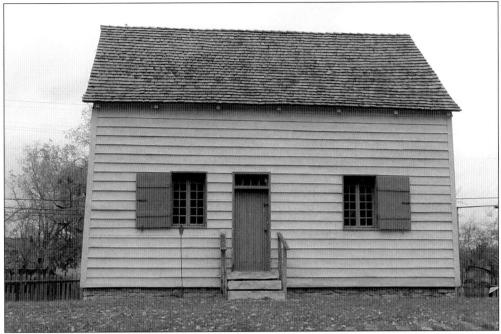

The Navarre Anderson Trading Post was built in 1789 by Utreau Navarre, uncle of Colonel Francois Navarre. It is the oldest wooden structure still standing in Michigan. Originally, Navarre used this structure as a depot for his fur trade business, but in 1798, he converted it to his family residence. The second owner of the building was Colonel John Anderson who figured prominently in the Battles of the River Raisin. In 1847, the Ilgenfritz family acquired the building and made it their homestead for many years, while they developed an extensive nursery industry in Monroe. It is located at 3775 North Custer Road.

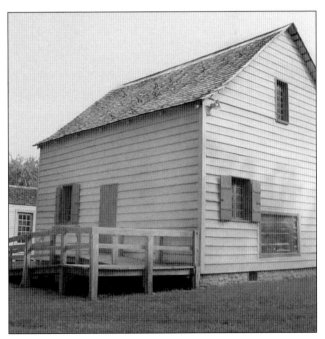

The Navarre Anderson Trading Post has been restored to its 1797 appearance. Bullet holes can be seen on the west side of the building. The caliber of the holes is too small for American and British muskets, but it is correct for Indian trade muskets. In 1972, the building was moved to its present location and in the process, many small artifacts were found between the walls and floor boards. The building was clapboarded in order to be authentic to 1797. Most French framed houses that were used for any length of time were clapboarded. A glassed-in area was set up so visitors can observe the log structure underneath.

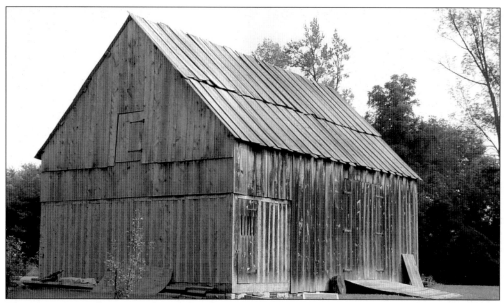

The Navarre Anderson Trading Post complex includes a replica 1790s French-Canadian-style barn. A bridge was donated by the Monroe Rotary Club in 1981, which allows visitors to park on the west side and cross the bridge to tour the complex. The complex is set up to represent the French pioneer period along the River Raisin. The grounds are developed with a number of interpretive features so visitors can have a self-guided experience. The trading area is stocked with replica period items.

A small building with a cooking fireplace was added to interpret the "separate" kitchen, which was a common feature adopted in order to protect the living quarters from potential fires. A replica clay oven typical of the time period is part of the setup. Lantern tours are held very year in the latter part of October. Monroe County's rich history comes alive in the glow of lanterns, fires, and torches, as costumed guides conduct evening group tours of the trading post complex. Visitors may walk the grounds of the complex at any time.

The battle fought near the current location of River Raisin Battlefield Visitor Center on January 22, 1813, was one of the largest engagements of the War of 1812. Of the 934 Americans who fought here, only 33 escaped death or capture. The massacre of wounded soldiers the following day shocked and enraged Americans throughout the Old Northwest Territory. Located on a portion of the battlefield, at 1403 East Elm Avenue, the visitor center tells the story of this very important battle through interesting and varied exhibits. The grounds are open year round and admission to the visitor center is free to the general public.

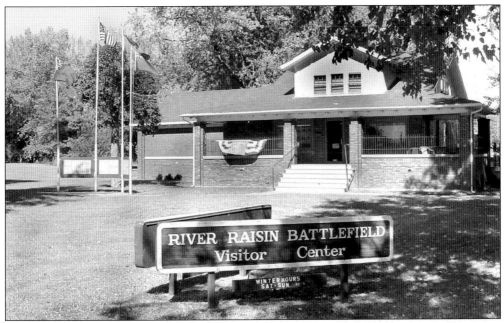

Every year, on the Saturday in January closest to the date of the battle, a commemoration ceremony is held at the River Raisin Battlefield Visitor Center. The noon memorial includes raising the flag, reading the names of the fallen, laying a wreath, and firing a salute. A speaker is scheduled for the afternoon.

Near the visitor center, a short interpretive trail guides visitors through the action that took place on the battlefield. A replica cannon and sled were made according to plans designed by a British artillery expert who served in Detroit prior to the War of 1812. Designed and assembled by then-Monroe County Historical Museum Director Matthew Switlik, the replica sled gun was unveiled on June 23, 2003.

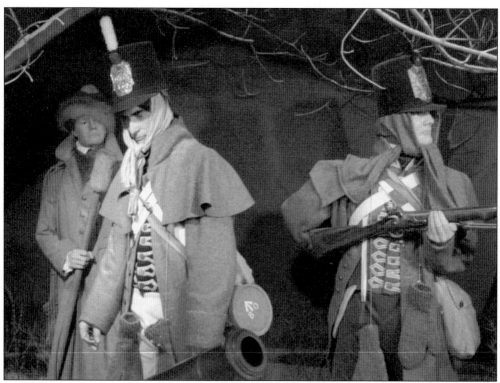

The displays inside the visitor center include dioramas and full-size British and American soldiers, as well as a fiber-optic map presentation on the Battle of the River Raisin. The stories of the various parties involved are told: British, American, Native American, and local settler. The logistics of the battles are also interpreted for the public.

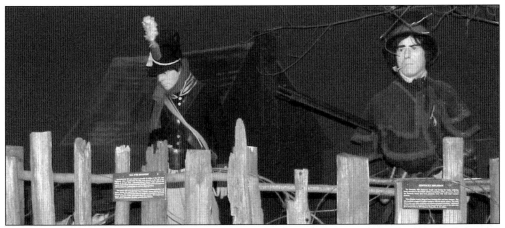

Interpretive displays tell the tale of what happened to the American army which included many local settlers. The American army, mainly composed of Kentucky volunteers, arrived in the area on January 18, 1813. They were reinforced with 100 men from the River Raisin. In the initial battle, the Americans drove the British and Indians into the woods. General Winchester arrived with reinforcements several days later, bringing the number of American troops to 934. In a counterattack, the Americans suffered heavy casualties. The River Raisin would finally be liberated on September 27, 1813. Destruction was so severe in the area that the River Raisin settlement remained impoverished for five years.

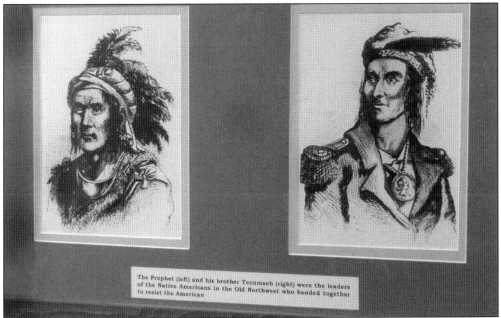

The Prophet (left) and his brother Tecumseh (right) were the leaders of the Native Americans in the Old Northwest who banded together to resist the American

Inside the visitor center, the story of the Native Americans' role in the battles and in the larger area is told. Tecumseh and his brother, the Prophet, were the leaders of a confederacy of Native Americans in the Old Northwest Territory who banded together with the British to drive the Americans from the area. On January 22, 1813, 800 Indians joined in an attack on the American positions on the River Raisin. The Americans reluctantly surrendered, and the British moved on to Detroit. The American wounded were left behind. Indians returned to the River Raisin the next day and massacred over 60 unarmed wounded Americans.

Over this ground (above) on January 18, 1813, 667 Kentuckians and nearly 100 local Frenchmen charged across the frozen river towards the British and Indian positions. The 63 British soldiers and 200 Potawatomi Indians made a brief stand there, then retreated with their canon into a wooded area one mile to the north where firing raged for several hours. Thirteen Americans died and 54 were wounded. The Americans established their camps in homes across the river. Across this same ground, during the second battle on January 22, the Indians closely pursued the retreating U.S. Seventeenth Infantry.

This cairn (left) was dedicated to the battle and massacre that occurred on this site in January of 1813. It was erected in 1904 by the Civic Improvement Society of the Women of Monroe. The 15-foot-tall pyramid made of boulders is one of Monroe's oldest monuments. It is located at corner of East Elm Avenue and North Dixie Highway.

Although earlier cemeteries, which have since disappeared, existed at Monroe and Front Streets and Monroe at Sixth Street, this sacred ground is the successor to the first parish cemetery established in 1794 and abandoned in 1830. The first cemetery was located west of Monroe on North Custer Road as part of St. Antoine's church land. Parishioners renamed their church St. Mary's, locating it at Elm Avenue and Monroe Street and consecrating a new burial ground on that site.

During the cholera epidemic of 1832, victims of all nationalities and religions were buried alongside the Roman Catholic parishioners to whom this cemetery was once dedicated. Today known as the Old Burial Ground, the site can be visited at any time by the general public. It is located on the west side of North Monroe Street.

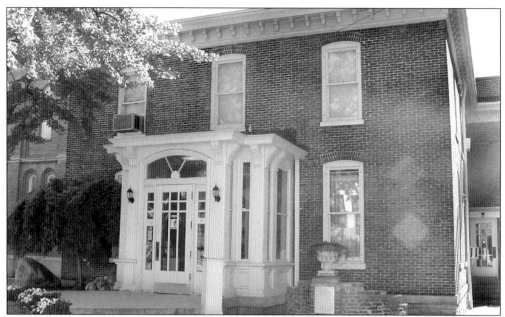

Although Dr. Eduard Dorsch (1822–1887), born in Bavaria, was a competent physician with degrees from Munich and Vienna, he was exiled when the 1848 German Revolution failed. Settling in Monroe, his love of freedom led him to make his home a station on the Underground Railroad. He later willed it for use as a public library. Opened in 1916 as a library, it houses an impressive Custer collection. It is located at 18 East First Street. Dr. Dorsch was a delegate to the first Republican Party Convention, elector from Michigan, and member of the State Board of Education. He devised charts which have long been used to trace a bullet's course in the human body. He established the spectacular American Lotus in Monroe's marshes.

The Monroe County Historical Country Store Museum is a replica of a store from the 1870s. The structure was built in the 1860s and served as the Papermill School until 1962. The school was named after the Christopher McDowell Papermill which was located across the River Raisin from the school. Today, the building houses an interpretive country store, which historically served many functions: trading post, post office, bar, grocery store, mail order catalogue, and dry goods store. Eggs and other farm produce were often traded for store merchandise. It served as a place to get news and make contact with the outside world. Located at 3815 North Custer Road, it is open to visitors twice a year and by appointment.

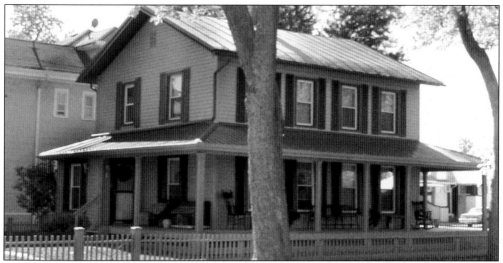

Elizabeth "Libbie" Clift Bacon was born in 1842 and raised in this house, originally located where the Monroe County Historical Museum stands today. It was moved to this site at 703 Cass Street in 1911. Judge Daniel Stanton Bacon, Elizabeth's father, was a man of means and position. Judge Bacon held many positions during his life in Monroe: schoolteacher, lawyer, a member of the Territorial legislature, a judge of probate, a director of a railroad, and director of a bank. He was one of Monroe's leading citizens. The building is privately owned today.

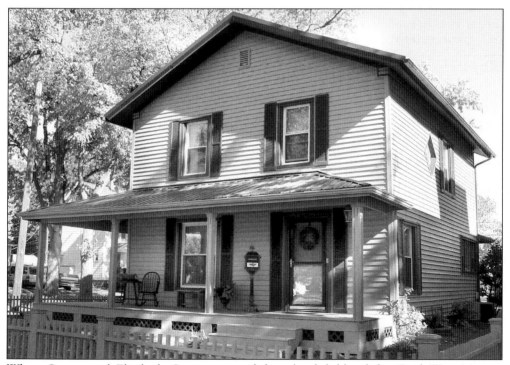

When George and Elizabeth Custer returned from battlefields of the Civil War, Monroe citizens would meet them at the train station and form a parade to escort them home. This home served as a temporary home for the Custers in 1868, and Libbie lived here for a time after her husband's death in 1876.

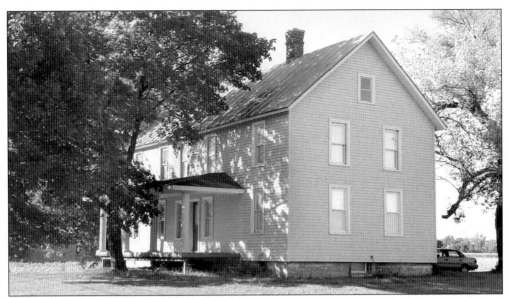

The Nevin Custer Farm was located north of the River Raisin and west of town. On August 22, 1871, George, his brother Nevin, and their wives, jointly purchased this house and 116 acres for $5,280. Nevin, whose rheumatic condition had saved him from the soldierly fate of his brothers, was the only one of the Custer line to have children. General Custer's favorite horse, Dandy, was buried in an orchard near the barn. Visitors to the farm included Buffalo Bill Cody and Annie Oakley. Located at 3048 North Custer Road, today the building is privately owned.

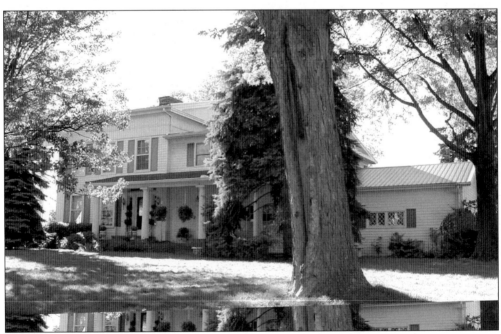

This stately example of Greek Revival architecture was built in the 1830s. The structure was home to Frederick Nims, who was an aide to General Custer during the Civil War. Renamed "Shadowland," after extensive remodeling in 1914, the house is now on the National Register of Historic Places and is privately owned. It is located at 206 West Noble.

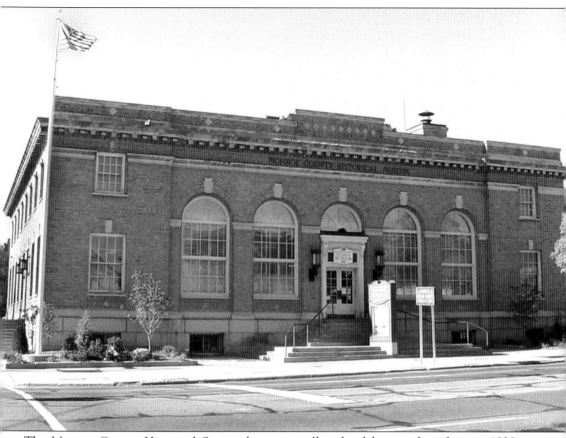

The Monroe County Historical Society began to collect local historical artifacts in 1938, housing them in the historic Sawyer House on East Front Street, before presenting them to the Historical Commission, established in 1967 by Monroe County. In 1972, through a generous gift by the La-Z-Boy Chair Foundation, the commission was able to purchase this imposing structure which was formerly the United States Post Office, erected in 1913. The museum, located at 126 South Monroe Street, has recently been renovated and features a wide array of displays that interpret every era in Monroe's heritage. The museum houses one of the largest collections of 18th- and 19th-century artifacts relating to southeast Michigan. Only a small percentage of the total collection can be exhibited at any one time, and many of the exhibits are changed throughout the year. The experience is self-guided; however, guided tours may be arranged by appointment. The museum also features a professionally-staffed archive.

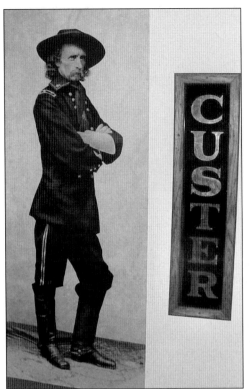

This is the entrance to the General George Armstrong Custer Exhibit. Housed on the second floor of the Monroe County Historical Museum, this is one of the nation's largest public exhibits on General George Armstrong Custer. The exhibit traces General Custer's genealogy and birth, his association with Monroe, his West Point experience, his Civil War victories, and his ultimate demise at Little Bighorn. Custer's interests in outdoor life, travel, target shooting, hunting, and taxidermy are also highlighted.

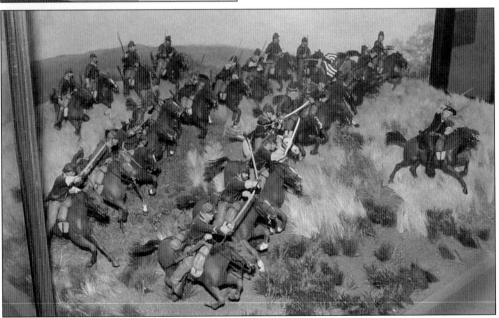

The effect of Custer and his legend can be seen in displays such as this Gettysburg Wheatfield battlefield diorama designed and modeled by a local miniatures artist. The life and work of Custer's widow, Elizabeth, is exhibited as well, as she remained steadfast to his memory until her death at age 91. The rest of the Custer family is not forgotten in the exhibit—they remained a fixture among Monroe's military families until after World War II.

In 1879, Little Bighorn Battlefield National Cemetery was established. A huge, white granite monument was erected on which the names of the dead were inscribed. In 1890, white marble headstones replaced wooden markers to designate the places where cavalrymen had fallen. The actual headstones from the Little Bighorn Battlefield site are in the exhibit at the Monroe Museum including: George Armstrong Custer, his brothers Tom and Boston, brother-in-law James Calhoun, and nephew Harry Armstrong Reed.

The story of the muskrat and its importance is told at the museum. Called "shishko" in the Potawatomi language, the muskrat was a source of food from the early history of Monroe County. When Frenchtown was almost destroyed during the War of 1812, the inhabitants would not have survived without the muskrat. Peter Navarre, the famous scout, was quoted as saying, "had it not been for the muskrats, the people must have starved." The muskrat tradition lives on today.

The Woodland Cemetery, at the south end of Jerome Street, holds the remains of George's brother, Boston, and his nephew, Harry Armstrong "Autie" Reed, both of whom died at Little Bighorn. "Autie" was the Reeds' only son and was only 18 years old at the time of his death. Here also lies the remains of General Custer's parents, Emanuel and Maria, and of his sister, Margaret Custer Calhoun Maugham. The graves of Libbie's parents, the Bacons, are in another section of the cemetery. Plots in Woodland Cemetery date from the earliest days of the Monroe area to the present.

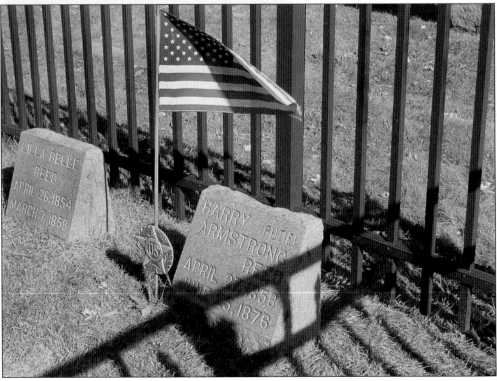

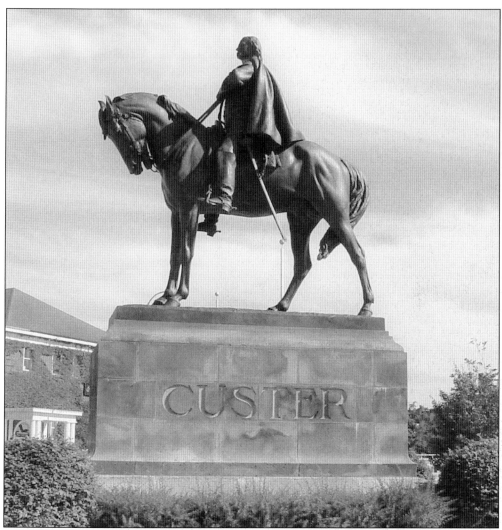

Born in New Rumley, Ohio, in 1839, George Armstrong Custer grew up in Monroe in the home of his half-sister, Mrs. David Reed. On February 9, 1864, he married Libbie Bacon, only daughter of Judge Daniel S. Bacon, at the Presbyterian Church. During the Civil War, he received six brevets and was made Major-General before he was 26 years old, a rare distinction. From 1866 until his death at the Battle of Little Bighorn, General Custer commanded the famous Seventh Cavalry Regiment, leading them in scouting and Indian fighting throughout Kansas and the Dakota Territory. This statue of General Custer, created by Edward C. Potter, was erected by the State of Michigan. It was unveiled by Mrs. Elizabeth B. Custer and dedicated by President William Howard Taft on June 4, 1910. The statue was rededicated on September 3, 1955 by the First Cavalry Division, of which Custer's Seventh Cavalry Regiment was a part. The memorial, located at the corner of West Elm Avenue and North Monroe Street, is regarded as one of the finest of its type in the world and is one of the most recognized in the Monroe area. It is an impressive sight, especially at night when it is highlighted by lighting.

Selected Bibliography

Books

Au, Dennis M. *War on the Raisin*. Monroe County Historical Commission, 1981.

Buckley, John McClelland. *History of Monroe County, Michigan*. Chicago: The Lewis Publishing Company, 1913.

Catton, Bruce. *Michigan: A History*. New York: W.W. Norton & Company, 1976.

Clifton, James A., Cornell, George L., and McClurken, James M. *People of the Three Fires: The Ottawa, Potawatomi, and Ojibway of Michigan*. Grand Rapids: The Michigan Indian Press, 1986.

Collections of the Pioneer Society of the State of Michigan. Lansing: Wynkoop Hallenbeck Crawford Company, 1907.

Dunbar, Willis Frederick. *Michigan: A History of the Wolverine State*. Grand Rapids: William B. Eerdmans Publishing Company, 1971.

Frost, Lawrence A. *The Custer Album: A Pictorial Biography of General George A. Custer*. Norman: University of Oklahoma Press, 1964.

Frost, Lawrence A. *Custer Slept Here*. Garry Owen Publishers, 1974.

Hatch, Thom. *The Custer Companion*. Stackpole Books, 2002.

Hogg, Victor and Korab, Balthazar. *Legacy of the River Raisin*. Monroe County Historical Society, 1976.

Monaghan, Jay. *Custer: The Life of General George Armstrong Custer*. Lincoln: University of Nebraska Press, 1959.

Naveaux, Ralph and Gruber, Shana. *A Brief History of the City and County of Monroe, Michigan: 1830–1930*. Monroe County Historical Museum, 2001.

The Presidency. Edited by Michael Nelson. New York: Smithmark Publishers, 1996.

River Raisin Battle & Massacre. City of Monroe, 1981.

Viola, Herman J. *Little Bighorn Remembered*. Rivilo Books, 1999.

Wing, Talcott E. *History of Monroe County*. New York: Munsell & Company Publishers, 1890.

Zeisler, Karl. *A Brief History of Monroe*. Monroe Evening News, 1969.

Articles

Naveaux, Ralph. "The Mighty Mushwa: The Muskrat Tradition in Monroe County, Michigan." Monroe County Historical Museum, 2001.

Internet

Bygones of Monroe. From Monroe County Library System.
 www.monroe.lib.mi.us/bygonesofmonroe/bygonesmonroe.htm
Monroe County, Michigan, Information and Local History. From Monroe County Library System.
 www.monroe.lib.mi.us/cwis/lochist.htm
St. Mary School: Monroe, Michigan.
 www.stmarymonroe.org/school/history.htm